T0209671

An Analysis of

Albert Hourani's

A History of the Arab Peoples

J. A. O. C. Brown

with Bryan R. Gibson

Published by Macat International Ltd
24:13 Coda Centre, 189 Munster Road, London SW6 6AW.

Distributed exclusively by Routledge
2 Park Square, Milton Park, Abingdon, Oxon OX14 4RN
711 Third Avenue, New York, NY 10017, USA

Routledge is an imprint of the Taylor & Francis Group, an informa business

www.macat.com
info@macat.com

Cataloguing in Publication Data
A catalogue record for this book is available from the British Library.
Library of Congress Cataloguing-in-Publication Data is available upon request.
Cover illustration: Etienne Gilfillan

ISBN 978-1-912302-64-2 (hardback)
ISBN 978-1-912127-69-6 (paperback)
ISBN 978-1-912281-52-7 (e-book)

Notice
The information in this book is designed to orientate readers of the work under analysis,
to elucidate and contextualise its key ideas and themes, and to aid in the development
of critical thinking skills. It is not meant to be used, nor should it be used, as a
substitute for original thinking or in place of original writing or research. References and
notes are provided for informational purposes and their presence does not constitute
endorsement of the information or opinions therein. This book is presented solely for
educational purposes. It is sold on the understanding that the publisher is not engaged
to provide any scholarly advice. The publisher has made every effort to ensure that
this book is accurate and up-to-date, but makes no warranties or representations with
regard to the completeness or reliability of the information it contains. The information
and the opinions provided herein are not guaranteed or warranted to produce particular
results and may not be suitable for students of every ability. The publisher shall not be
liable for any loss, damage or disruption arising from any errors or omissions, or from
the use of this book, including, but not limited to, special, incidental, consequential or
other damages caused, or alleged to have been caused, directly or indirectly, by the
information contained within.

CONTENTS

WAYS IN TO THE TEXT

Who Was Albert Hourani? 9
What Does *A History of the Arab Peoples* Say? 10
Why Does *A History of the Arab Peoples* Matter? 11

SECTION 1: INFLUENCES

Module 1: The Author and the Historical Context 15
Module 2: Academic Context 20
Module 3: The Problem 24
Module 4: The Author's Contribution 28

SECTION 2: IDEAS

Module 5: Main Ideas 33
Module 6: Secondary Ideas 38
Module 7: Achievement 42
Module 8: Place in the Author's Work 46

SECTION 3: IMPACT

Module 9: The First Responses 51
Module 10: The Evolving Debate 56
Module 11: Impact and Influence Today 60
Module 12: Where Next? 64

Glossary of Terms 69
People Mentioned in the Text 77
Works Cited 81

THE MACAT LIBRARY

The Macat Library is a series of unique academic explorations of seminal works in the humanities and social sciences – books and papers that have had a significant and widely recognised impact on their disciplines. It has been created to serve as much more than just a summary of what lies between the covers of a great book. It illuminates and explores the influences on, ideas of, and impact of that book. Our goal is to offer a learning resource that encourages critical thinking and fosters a better, deeper understanding of important ideas.

Each publication is divided into three Sections: Influences, Ideas, and Impact. Each Section has four Modules. These explore every important facet of the work, and the responses to it.

This Section-Module structure makes a Macat Library book easy to use, but it has another important feature. Because each Macat book is written to the same format, it is possible (and encouraged!) to cross-reference multiple Macat books along the same lines of inquiry or research. This allows the reader to open up interesting interdisciplinary pathways.

To further aid your reading, lists of glossary terms and people mentioned are included at the end of this book (these are indicated by an asterisk [*] throughout) – as well as a list of works cited.

Macat has worked with the University of Cambridge to identify the elements of critical thinking and understand the ways in which six different skills combine to enable effective thinking.
Three allow us to fully understand a problem; three more give us the tools to solve it. Together, these six skills make up the **PACIER** model of critical thinking. They are:

ANALYSIS – understanding how an argument is built
EVALUATION – exploring the strengths and weaknesses of an argument
INTERPRETATION – understanding issues of meaning

CREATIVE THINKING – coming up with new ideas and fresh connections
PROBLEM-SOLVING – producing strong solutions
REASONING – creating strong arguments

To find out more, visit **WWW.MACAT.COM.**

CRITICAL THINKING AND *A HISTORY OF THE ARAB PEOPLES*

Primary critical thinking skill: EVALUATION
Secondary critical thinking skill: INTERPRETATION

Few works of history make as well-structured a case for the importance of studying continuity, rather than change, than Albert Hourani's *A History of the Arab Peoples.*

Hourani's work had three major aims: to refute the idea that Arab society stagnated between 1000 and 1800; to study the period through the lens of diverse Arab, rather than Muslim, history; and to stress intellectual and cultural continuity. All of these intentions were the product of the author's evaluation of a great mass of secondary sources, many of them devoted to arguing for ideas that contradicted his, and it demanded considerable skill to synthesize from them a coherent and well-evidenced counter-argument.

Hourani was able to do this largely because his grasp of the relevance and adequacy of his predecessors' arguments was second to none; his achievement lies in his ability to reject the reasoning of other historians while still making good use of their evidence. In this task, he was aided by an interpretative skill almost equal to his powers of evaluation; *A History of the Arab Peoples* is also a monument to the importance of properly understanding the meaning of available evidence.

ABOUT THE AUTHOR OF THE ORIGINAL WORK

British historian **Albert Hourani** was born in Manchester, England, in 1915. His parents came from the Lebanon, so he grew up speaking both Arabic and English. Hourani graduated from Magdalen College, Oxford, and during World War II travelled across the Middle East, working for the British Foreign Office. He dedicated his post-war academic life to studying the Arab world, bringing his intimate knowledge of the region to his later work in the field of Middle Eastern Studies. Hourani died in 1993 at the age of 77.

ABOUT THE AUTHORS OF THE ANALYSIS

Dr J.A.O.C. Brown was awarded his doctorate by the University of Cambridge for a thesis on Anglo-Moroccan relations in the 18th and 19th centuries.

Dr Bryan Gibson holds a PhD in International History from the London School of Economics (LSE) and was a post- doctoral research fellow at the LSE's Centre for Diplomacy and Strategy and an instructor on Middle Eastern politics in the LSE's Department of International History and the University of East Anglia's Department of Political, Social and International Studies (PSI). He is currently on the faculty of Johns Hopkins University.

ABOUT MACAT

GREAT WORKS FOR CRITICAL THINKING

Macat is focused on making the ideas of the world's great thinkers accessible and comprehensible to everybody, everywhere, in ways that promote the development of enhanced critical thinking skills.

It works with leading academics from the world's top universities to produce new analyses that focus on the ideas and the impact of the most influential works ever written across a wide variety of academic disciplines. Each of the works that sit at the heart of its growing library is an enduring example of great thinking. But by setting them in context – and looking at the influences that shaped their authors, as well as the responses they provoked – Macat encourages readers to look at these classics and game-changers with fresh eyes. Readers learn to think, engage and challenge their ideas, rather than simply accepting them.

'Macat offers an amazing first-of-its-kind tool for interdisciplinary learning and research. Its focus on works that transformed their disciplines and its rigorous approach, drawing on the world's leading experts and educational institutions, opens up a world-class education to anyone.'

Andreas Schleicher,
Director for Education and Skills, Organisation for Economic
Co-operation and Development

'Macat is taking on some of the major challenges in university education … They have drawn together a strong team of active academics who are producing teaching materials that are novel in the breadth of their approach.'

Prof Lord Broers,
former Vice-Chancellor of the University of Cambridge

'The Macat vision is exceptionally exciting. It focuses upon new modes of learning which analyse and explain seminal texts which have profoundly influenced world thinking and so social and economic development. It promotes the kind of critical thinking which is essential for any society and economy.
This is the learning of the future.'

Rt Hon Charles Clarke, former UK Secretary of State for Education

'The Macat analyses provide immediate access to the critical conversation surrounding the books that have shaped their respective discipline, which will make them an invaluable resource to all of those, students and teachers, working in the field.'

Professor William Tronzo, University of California at San Diego

WAYS IN TO THE TEXT

KEY POINTS

- Albert Hourani was a scholar of the Middle East. He was born in Manchester, England, in 1915, the son of Lebanese immigrants.

- *A History of the Arab Peoples* offers a broad outline of the Arab civilization, from the founding of Islam in the seventh century right through to the twentieth century.

- Instead of being a traditional political history, *A History of the Arab Peoples* focuses more on the cultural, economic, and social developments that had a profound impact on the formation of the Arab civilization.

Who Was Albert Hourani?

Albert Hourani was a highly respected historian of the Middle East and is considered to be one of the founding scholars of Middle East Studies.

Hourani was born in 1915 in Manchester, England, where his Lebanese Christian parents had emigrated to trade textiles. Despite where they lived, the Hourani family spoke Arabic at home. They valued education highly, and the teenage Hourani attended an English school in London. He went on to study at Magdalen College at the University of Oxford.

After graduating, Hourani found work as a lecturer. He then left England for the Middle East, taking up a position at the American University of Beirut, where his father had studied before him. When World War II* broke out, Hourani went to work for the Research Department of the British Foreign Office. His role involved travel across the Middle East.

After the war, Hourani returned to Oxford to pursue a career in academia, which he devoted to studying the Arab world. In 1958, he became director of Oxford's Middle East Centre,[1] where he remained for over 20 years. Despite retiring in 1979, Hourani remained a visiting professor at a number of universities in Europe, America, and the Middle East.

Calling upon his Arab roots and fluency in Arabic, Hourani distilled a lifetime of research into his most important book, *A History of the Arab Peoples*. It was published in 1991, just two years before he died.

What Does *A History of the Arab Peoples* Say?

A History of the Arab Peoples covers an impressive sweep of time. It offers a broad overview of the Arab civilization from the founding of Islam in the seventh century through to the end of the 1980s.

Written in chronological order, the book doesn't put forth a central argument, though Hourani did have clear objectives for his work. Many Western scholars of the twentieth century saw Arab civilization as stagnant. They believed that the Middle East had been in decline since the tenth century. Hourani set out to counter that notion. To do so, he examined both the changes and the continuities that can be seen in the Arab world over the course of its history.

Rather than looking at politics, Hourani focuses on what is called socio-cultural aspects of Arab life. The book weaves together historical, cultural, economic, religious, and social trends, providing a wealth of detail about the many dynamic and evolving aspects of life in the Middle East. Hourani uses these trends and details to persuade the

reader of the continuing vitality of Arab societies.

Hourani's second aim was to express his belief in and support for a concept called Arab unity.* He believed that the shared culture and values of the Arab world gave all the people of this region a cohesive identity. They might live in different countries. They might live at different times. They might have different customs or practice different faiths. Despite their diversity, they are a recognizable group. Hourani identified two factors that underpinned this cultural unity: the dominant Arab religion, Islam, and the Arabic language.

Packed with information, *A History of the Arab Peoples* is easy to read. Hourani wanted the text to be accessible to the general reader. The book was an immediate success when it was published in 1991. Unusually for a social and cultural history, it appeared on the *New York Times* nonfiction bestseller list and stayed there for several weeks.

Academic journals praised the book, as did the popular press, where it was described as "richly rewarding."[2] History professor and reviewer Donald Malcolm Reid commented, "No brief review can do justice to its many threads: cities and countryside, peasants and Bedouin, ulama and Sufi saints, imperialism* and nationalism,* urbanization and population growth, women and men, music and architecture, education and religion." A *New York Times* review called the book "a splendid achievement that can be read with profit by rank beginners and jaded specialists."[3]

A History of the Arab Peoples has been reissued twice since 1991 and been translated into French, German, Japanese, and Arabic. As an introduction to the history of the Middle East it remains an invaluable work of reference.

Why Does *A History of the Arab Peoples* Matter?

A History of the Arab Peoples provides an important introduction to the wider field of Middle Eastern Studies. It stands out for two reasons. The first is the length of time it covers. Hourani starts his book early

in the seventh century. That was the date when Muhammad*—viewed by non-Muslims as the founder of Islam* and by most Muslims as the last prophet that God sent to mankind—began preaching in Mecca.*

Hourani's book goes on to chart the course of the Arab civilization over the next fourteen centuries. His final chapters cover the Arab world after 1967, the year when Israel and an alliance of Arab States battled each other in the Six-Day War.* Israel won the war quickly, demonstrating its clear military superiority in the process. This victory shifted the balance of power in the Middle East and led to continuing tensions in the region.

The second reason why *A History of the Arab Peoples* remains a compelling introduction to the Middle East is because of the range of subjects it covers. It isn't a narrow political overview of the Middle East. Instead, Hourani looks at a whole range of cultural, economic, and social developments within Arab society. Scholars looking at other civilizations, as well as by those working in Middle Eastern studies, have since adopted this nuanced approach.

The views Hourani expressed in *A History of the Arab Peoples* are also relevant in the field of politics and policy-making. Internal conflict has marked the recent history of the Middle East. There is division between nations, between faiths and between ethnic groups. Certain groups from the Middle East have voiced uncompromising hostility to the West.

As a result, an old question has re-emerged among policy makers. What is the nature of the relationship between the Arab world and the West? Influential scholars like historian Bernard Lewis* and political scientist Samuel P. Huntington have voiced strong opinions. They say that the Middle East is fundamentally opposed to the modern world. That belief has helped to guide the course of Western foreign policy in the Middle East. Hourani offers a different perspective, showing the Middle East as a dynamic, evolving society that can adapt and has

much to offer the world. *A History of the Arab Peoples* explains his views.

NOTES

1 Roger Hardy, "Obituary: Albert Hourani," *The Independent*, January 18, 1993.

2 Donald Malcom Reid, "Review: *A History of the Arab Peoples by Albert Hourani*," *The International History Review* 14/2 (1992): 348.

3 L. Carl Brown, "Empires in the Sand: Review: *A History of the Arab Peoples by Albert Hourani*," *New York Times*, March 31, 1991.

SECTION 1
INFLUENCES

MODULE 1
THE AUTHOR AND THE HISTORICAL CONTEXT

KEY POINTS

- *A History of the Arab Peoples* is an important book in introducing students to the history of the Arab civilization.

- The son of Lebanese immigrants in England, Albert Hourani's personal ties to the Middle East and his experience in the region during World War II* helped shape his interest in the Arab world and the Middle East.

- Hourani's academic interests were cultural and social history, rather than political history.

Why Read This Text?

Albert Hourani's *A History of the Arab Peoples* is an impressive social and cultural history of one of world's most accomplished civilizations. It is one of very few scholarly works that traces the development of Arab civilization from the emergence of Islam in the seventh century right through to the end of the 1980s. Published in 1991, it quickly became a bestseller.

A History of the Arab Peoples is based on decades of Hourani's own research and his in-depth study of secondary material about the history and culture of the Arab world. As Aziz Al-Azmeh, a professor of Middle Eastern Studies at Central European University, noted, Hourani "is fully in command of the entire patrimony of historians of the Arabs, and is also fully versed in the most recent scholarship on the vast array of topics included in this book."[1]

Hourani introduces Arab civilization to readers of all levels in an accessible and comprehensive way. While the book was aimed

> 66 This book by one of the most distinguished scholars of the Arab world and the Middle East is a splendid achievement that can be read with profit by rank beginners and jaded specialists. It is, moreover, written with the grace and wisdom that those who know Mr. Hourani's works have come to expect. 99
>
> L. Carl Brown, *New York Times*

primarily at undergraduate students and the general public, reviewer Donald Malcolm Reid hailed it as a "masterful synthesis" that scholars would also find "richly rewarding."[2] In addition, Hourani avoided many of the biases and problems associated with Orientalist* scholarship: the study of how Western culture has traditionally described the East. The Palestinian American scholar Edward Said* highlighted the problems with that scholarship in his 1978 book, Orientalism, which condemned patronizing Western attitudes towards Middle Eastern, Asian, and North African societies.[3] Speaking about *A History of the Arab Peoples*, Aziz Al-Azmeh* said: "Here we have for the first time in English, a book on the history of the Arabs that can be recommended to students and general readers without reservation."[4]

Author's Life

Albert Hourani was one of the most important scholars of the second half of the twentieth century in the field of Middle Eastern studies. He was influential not only because of his own work, but also because he trained a new generation of Middle Eastern history scholars during the 1940s and 1950s when he was a lecturer at the University of Oxford.

Born in 1915 in Manchester, England, to Lebanese Christian parents who had emigrated there to trade textiles, Hourani's background was typical of the new Arab elites (often Christian) that

emerged in the late nineteenth and early twentieth centuries. These groups enabled much of the trade between Europe and the Middle East, while also sharing modern European ideas and attitudes that helped stimulate the movement known as *Al*-Nahda,*—"the awakening." That movement celebrated the culture and heritage of the Middle East and brought about a cultural and intellectual revival in the region.

Hourani spoke Arabic at home with his family, but received a typical English education—first at public school in London and then at Oxford's Magdalen College. In the late 1930s, he spent three years living in Lebanon working as a lecturer at the American University of Beirut.

During World War II,* Hourani served the British government, specializing in Middle Eastern affairs. He worked in the Research Department of the Foreign Office, where he met the historians Arnold Joseph Toynbee* and H. A. R. Gibb.* The work and ideas of both men influenced Hourani's later academic career. In the 1940s, Hourani was based at the Office of the Minister of State in Cairo, a role which involved extensive travel throughout the Middle East.

After the war he returned to Oxford to continue an academic career, becoming a research fellow of Magdalen College. In 1959, he was appointed director of Oxford's newly established Middle East Centre,[5] a position he held until he retired in 1979. Hourani died in January 1993, less than two years after the publication of *A History of the Arab Peoples*.

Author's Background

Hourani's career must be viewed in the context of two events:
- The rise of Arab nationalism* between the 1920s and the 1960s. This encouraged cultural renewal and cooperation between Arab societies.
- The Cold War* from 1947 to 1991, during which the

superpowers* of the United States and the Soviet Union* competed for world influence.

Early in his working life, Hourani came into contact with the idea of Arab nationalism.* The American University of Beirut, where he worked between 1936 and 1939 was a center for the Arab intellectual and cultural revival known as Al-Nahda *—"the awakening." That revival was closely tied to the political idea of Arab nationalism.* Hourani came into contact with some leading intellectual figures of those movements, such as the Syrian Arab intellectual Constantine Zurayk,* the Lebanese-Egyptian writer and historian George Antonius,* and the Lebanese philosopher Charles Malik.*

During the 1950s and 1960s, the movement took a different turn. Arab nationalist military officers in Egypt, Iraq, Yemen, and Libya ejected their countries' pro-Western monarchies and established revolutionary regimes in their place. Along with Syria, the new leaders of these countries wanted to unify all the Arab states into one nation, a concept known as Arab unity.*

However, this political development led to conflict in the Middle East. While some countries embraced the idea of Arab unity, others opposed it. In addition, the overthrow of those pro-Western monarchies* led to competition in the region between the United States and the Soviet Union, with both superpowers trying to exert their influence in the region.

Military and political crises followed. In 1956 came the Suez Crisis.* The years between 1962 and 1970 saw the Yemen Civil War. The Lebanese Civil War* broke out in 1975, lasting until 1990 and the Iran-Iraq War* started in 1980, continuing until 1988.

It was in this context of heightened tension and division among different communities and faiths that Hourani wrote *A History of the Arab Peoples*. In many ways, his book looks back to the ideals of Arab nationalism.* During a time of division, Hourani reminded his readers of the shared culture, heritage, and achievements of the Middle East.

NOTES

1 Aziz al-Azmeh, "Review: *A History of the Arab Peoples* by Albert Hourani," *History Workshop Journal* 40/1 (1995): 249–50.

2 Donald Malcolm Reid, "Review: Albert Hourani, *A History of the Arab Peoples*," *The International History Review* 14/2 (1992): 348.

3 Edward Said, *Orientalism* (New York: Vintage Books, 1979).

4 Aziz al-Azmeh, "Review," 249.

5 Roger Hardy, "Obituary: Albert Hourani," *The Independent*, January 18, 1993.

MODULE 2
ACADEMIC CONTEXT

KEY POINTS

- *A History of the Arab Peoples* is a classic text within the field of Middle Eastern studies. It is primarily concerned with analyzing the history, culture, politics, economies, and geography of the Middle East.
- Albert Hourani is one of the founding scholars of Middle Eastern studies. He helped to adapt the field from the previous discipline of Oriental studies.*
- Hourani was looking to emphasize the real-life experiences of people living in the Middle East.

The Work in its Context

Until the late 1970s, European scholarship that looked at the Middle East was part of the wider discipline of Oriental Studies.* Covering both the Middle and Far East, Oriental Studies* focused on philology* (the development of language) and literature.

In 1978, the Middle Eastern specialist Edward Said* fiercely criticized Oriental Studies.* He accused its main specialists, notably the British historian Bernard Lewis,* of portraying Arab and Islamic culture as backward and trapped somewhere between tradition and modernity.[1]

Said's criticisms ushered in a change in the way scholars studied the Middle East, and Oriental Studies* became seen as outdated. Disciplines that focused on particular geographical areas, such as the Middle East, or on particular religions, such as Islam, began to replace it.

As director of the University of Oxford's Middle East Centre, Albert Hourani was among the first scholars to adapt Oriental

> **❝** Hourani, a doyen of Middle Eastern scholarship whose previous works have become required reading for students of the region, has contributed still another volume that should be required reading for those with more than a passing interest in the subject. **❞**
>
> Don Peretz, *Annals of the American Academy of Political and Social Science*

Studies* to the new interdisciplinary framework of what became known as Area Studies.* These new disciplines placed less emphasis on literary sources and philology. Instead, they took a broader view, looking at economic, social, and cultural developments within societies. They also started using research methods from the social sciences and humanities that had not been applied to the field before.

Overview of the Field

Today, the field of Middle Eastern studies (sometimes called Near Eastern studies) focuses on the history, culture, politics, economies, and geography of the Middle East region. This geographical region extends from North Africa in the west to the Horn of Africa in the south and the Chinese frontier in the east. This region contains a number of modern nations, including:

Egypt	Oman
The Gulf States	Palestine
Iran	Saudi Arabia
Iraq	Somalia
Israel	Sudan
Jordan	Syria
Kuwait	Turkey
Lebanon	Yemen

In most of these countries, the majority of the population is ethnically Arab. The populations of Iran, Israel, and Turkey are ethnically distinct, but they are often grouped together with the ethnic Arab countries for two reasons. The first is geographical proximity, as Iran, Israel and Turkey all lie on the borders of the ethnic Arab world. The second is the overlapping histories of these groups. For example, the ethnically Turkish Ottoman Empire* ruled over the Arab territories of modern-day Algeria, Egypt, Iraq, Israel, Lebanon, Syria, and Tunisia for centuries.

In the nineteenth century, European countries assumed control of much of the Middle East. After World War II,* these empires started to break up, and the nations of the Middle East began to gain independence. Twenty-two independent Arab states came into being in the twentieth century and this resulted in a vast expansion of the field of Middle Eastern studies.

Academic Influences

While working as a government researcher at the Foreign Office in London during World War II,* Hourani came into contact with the historians H. A. R. Gibb* and Arnold Toynbee.* They both became key influences on his work. Gibb was a professor of Arabic, who also spoke Hebrew and Aramaic. Like Gibb, Hourani believed in the importance of speaking and understanding the language of the peoples he studied.

Toynbee was one of the most important historians of the mid-twentieth century, best known for his 12-volume work A Study of History, published between 1934 and 1961. In it, Toynbee charted the rise and fall of 19 world civilizations. Hourani followed Toynbee by choosing to make a civilization his object of study.

Several of Hourani's contemporaries, including scholars like Marshall Hodgson,* Jacques Berque,* Ira Lapidus,* and André Raymond* also influenced his approach. They aimed to firmly root

the study of Arab and Muslim history in the sources and experiences of the societies themselves. While Hourani showed great respect for the linguistic and philological rigor of Orientalist scholars like Gibb, he and his contemporaries wanted to put more emphasis on the actual experience of people living in the Middle East.

The fourteenth century historian Ibn Khaldun,* regarded as one of the most significant historians of the Muslim world, also had an important impact on Hourani. Ibn Khaldun's most famous work, Kitab al-'Ibar (*The Book of Learning by Example*), was an ambitious world history—an early yet sophisticated analysis of social change. In *A History of the Arab Peoples*, Hourani used information about Khaldun's life as source material. He also drew on Khaldun's concept of "asabiyyah"* (group loyalty), which he believed was still relevant to the Arab peoples in modern times.[2]

NOTES

1 Edward Said, *Orientalism* (New York: Vintage Books, 1979).

2 Albert Hourani, *A History of the Arab Peoples*, 3rd ed. (London: Faber and Faber, 2013), 1–4.

THE PROBLEM

KEY POINTS

- The core question of *A History of the Arab Peoples* is: how have historical processes of change and continuity shaped the Arab societies of the Middle East since the emergence of Islam in the seventh century?

- Earlier works in this field tended to characterize the Arab civilization as having been in decline since the start of the first millennium (1000 c.e.), an argument that Edward Said* criticized as being derogatory and inaccurate.

- Hourani took a middle ground in this debate. On the one hand, he had respect for some orientalist scholarship. On the other, he rejected the notion that the Arab civilization had been in decline.

Core Question

Albert Hourani's core concern in *A History of the Arab Peoples* is to explain how the historical processes of change and continuity have shaped the Arab societies of the Middle East since the emergence of Islam in the seventh century. At the time the text was published in 1991, the major debate among historians who studied the Middle East was whether the European scholars who had worked in the discipline of Oriental Studies* had distorted the West's understanding of the Arab world. The Palestinian American scholar Edward Said* said they had. He attacked the Orientalists, saying their work presented the Arab world in a patronizing manner, a direct result of the imperialist culture in which they were working.

A History of the Arab Peoples addresses this debate cleverly and subtly.

> ❝ The subject of this book is the history of the Arabic-speaking parts of the Islamic world, from the rise of Islam until the present day … It would be possible to argue that the subject is too large or too small: that the history of the Maghrib* is different from that of the Middle East, or that the history of the countries where Arabic is the main language cannot be seen in isolation from that of other Muslim countries. A line has to be drawn somewhere, however, and this is where I have chosen to draw it. ❞
>
> Albert Hourani, *A History of the Arab Peoples*

By showing that there was both continuity and change in Arab history, Hourani clearly demonstrates that Arab society was much more dynamic than the Orientalist scholars had allowed.

Similarly, by choosing to look at cultural and social aspects of Arab history, Hourani revealed how narrow the Orientalist approach, which mainly focused on the political history of the region, had been. Successive invasions of the Middle East meant that for many centuries the Arab peoples had not held political control of their homelands. As a result, Orientalists tended to see Arab society as passive—acted on, rather than acting. Their excessive focus on political history meant they failed to see how Arab society had expressed itself in many other ways.

The Orientalists' dependence on European sources about the Middle East, rather than sources and records drawn from Arab societies themselves, made the problem worse. Hourani's emphasis on using Arab sources alongside material from elsewhere showed that he did not agree with this approach.

Some people also accused Orientalists of having a tendency to view the Middle East as defined only or primarily by its religious and cultural character. The Orientalists' concept of Islam as a fixed,

unchanging entity fed into their view of Arab society as stagnant—largely immune to the historical processes of change and development witnessed elsewhere. Hourani was able to disprove this notion simply by showing how much *had* changed in Arab society over time.

The Participants

Hourani wanted to develop a richer approach to Arab history. One way to do that was to use new methodological approaches to history—different ways of uncovering information. He wasn't alone in this effort, as some of his leading contemporaries in Middle Eastern Studies were doing the same thing. The American scholar Ira Lapidus* was using literary resources to explore socio-political structures.* The American historian Marshall Hodgson* was examining the history of the Middle East in the context of world history. The French social historian André Raymond was studying medieval Cairo and looking at how to reconstruct complex social relationships of the past.*

Hourani's approach can be seen in four key aspects of the book:

- The strong sense of empathy for the societies that were the subjects of *A History of the Arab Peoples.*

- His emphasis on the importance of the lived experience and the ongoing development of those societies.

- The attention he pays to the significance of the apparently mundane details of everyday life. Hourani shows how this can reveal profound aspects of a society's structure and attitudes.

- A focus on trying to understand Arab societies on their own terms, rather than judging them—explicitly or implicitly—in relation to the West.

The Contemporary Debate

A History of the Arab Peoples was aimed primarily at students and

general readers. As a result, it goes out of its way to avoid engaging in historiographical* debates and academic controversies. Nonetheless, the book provided a strong counterargument to the scholarship that presented the Middle East as a region in perpetual decline.

Hourani accepted Said's argument that a great number of Western studies were biased and flawed in their conclusions about the Middle East. However, he also believed that many Western scholars of Islam and the Middle East did have valid insights into the Arab world. His 1991 collection of essays, Islam in European Thought, reflected this deep respect. These essays explore how European ideas about Islam were formed and looked at the writers who helped develop those ideas.[1]

Overall, Hourani's work can be seen as an attempt to steer a middle course between two opposing strands of scholarship. *A History of the Arab Peoples* was generally well received and remains respected as a text that tried to give a voice to the perspectives of Arabs themselves, while not entirely rejecting the importance of others speaking about them. The book also made an important contribution to the debate about how to study the Middle East and Islam. In it, Hourani suggests that rather than adopting a narrow focus on political history, readers should consider social and cultural developments, too.

NOTES

1 Albert Hourani, *Islam in European Thought* (Cambridge: Cambridge University Press, 1991), 62–3.

MODULE 4
THE AUTHOR'S CONTRIBUTION

KEY POINTS

- Hourani provides a history of the Arab peoples between the seventh century and the end of the twentieth century.
- He believes all the people of the Middle East are united by language and culture.
- Hourani's book is a reminder that the Middle East should not be viewed solely in terms of its religious identity.

Author's Aims

Albert Hourani's main objective when writing *A History of the Arab Peoples* was to provide "a history of the Arabic-speaking parts of the Islamic world, from the rise of Islam until the present day."[1] This aim is reflected in the chronological structure of the work, which is split into five main sections:

- The rise of Islam and the establishment of the caliphate,* a form of Islamic government, between the seventh and tenth centuries

- The subsequent development of Arab Muslim societies until the fifteenth century.

- The establishment and influence of the Ottoman Empire* in the region between the sixteenth and eighteenth centuries.

- The impact of European expansion into the Middle East between 1800 and 1939.

- The age of Arab nation-states after 1939.

Despite this structure Hourani wanted to avoid examining a

> ❝ The idea of decline is a difficult one to use, however … Rather than speaking of decline, it might be more correct to say that what had occurred was an adjustment of Ottoman methods of rule. ❞
>
> Albert Hourani, *A History of the Arab Peoples*

"meaningless procession of dynasties in Islamic history."[2] Instead, he aimed to provide an overview of the social, economic, intellectual, and cultural dimensions of the development of Arab societies.

In addition, Hourani wanted to show that the societies and periods covered by the work could be studied within an "Arab" framework rather than an Islamic or Muslim framework. Hourani's decision to use an Arab framework reveals his belief in the idea of Arab unity: people unified by the Arabic language and Arab culture. This belief probably reflects the early influence of Arab nationalism on Hourani's thought. He accepted the importance of contextualizing this analysis within the wider perspective of the Muslim world. Yes, the majority of the Arab peoples were Muslim. But by looking at their cultural rather than their religious identity, Hourani was able to explore the variety and detail of different experiences within the Arab world.

Approach

Unlike most historical texts, *A History of the Arab Peoples* does not set out to ask a core question or provide a central idea. Instead, Hourani's aim is to provide a broad overview of an entire civilization. He uses a standard historical method—involving archival research and a wide range of historical and contemporary texts—to construct his narrative. This approach allows him to reveal aspects of Arab society or civilization to his readers that might have otherwise been overlooked.

A History of the Arab Peoples puts forward three key ideas:

1. The need to understand the continuity of Arab cultural development over time. Hourani rejects the idea that Arab civilization had stagnated between 1000 and 1800. The political and cultural influence of both the Turkish and Persian worlds markedly shaped Arab societies during these years. But Hourani argues that while Arab communities adapted in order to survive, they also preserved a culture of their own.[3]

2. The need to appreciate the diversity of Arab civilization. While arguing for a sense of unity amongst the Arab peoples, Hourani acknowledges the variations in Arab culture between different regions. In addition, he discusses the ways in which Arab societies borrowed from foreign cultures to create new cultural forms. One example he cites was the emergence of an Arab-Ottoman culture under the Ottoman Empire* (1299–1923).[4]

3. The importance of intellectual and cultural continuity in Arab societies. Despite his chronological approach, Hourani does not focus on political events or figures. Instead, he emphasizes the structures that underpinned social and cultural development, like urban culture and scholarly elites. This helps him to explain the nature of these societies.

Hourani's major themes and the narrative structure he uses to present them, create an impression of Arab history as a patchwork: diverse and incorporating many elements, but ultimately a single structure.

Contribution in Context

A History of the Arab Peoples was published in 1991, over a decade after Edward Said's* seminal work, Orientalism. Said argued that in-built bias and prejudice had undermined Western studies of the Middle East.[5] Like Said, Hourani believed that it was wrong to view Arab societies as

having spent centuries in decline. Although, Hourani also considered Said's conclusions flawed. His work aimed to find a balance: to show the true dynamism of the Arab peoples, while also confirming that much Western scholarship did have some validity.

Hourani developed a new approach to the study of non-Western societies or civilizations. He demonstrated the need to use a wide range of methodologies to study a given society, from economic perspectives to literary analysis. Hourani also argued that historians studying a particular society had to be able to speak and read the language of that society to access their source material effectively. This linguistic ability would become a standard requirement for people wanting to enter the field of Area Studies.*

Since the 1970s, political Islam has replaced Arab nationalism* as the key source of identity in the Arab world. Today, for many Arabs, identity is viewed largely in terms of sect, such as Sunni* or Shi'a Muslim. This change had occurred before Hourani wrote *A History of the Arab Peoples* but one of Hourani's key contributions is to remind readers that the Middle East should not be viewed in terms of its religious identity alone.

NOTES

1 Albert Hourani, *A History of the Arab Peoples*, 3rd ed. (London: Faber and Faber, 2013), xiii.

2 Hourani, *A History of the Arab Peoples*, 212.

3 Albert Hourani, *The Modern Middle East: A Reader*, ed. Albert Hourani, Philip S. Khoury, and Mary C. Wilson (London: I. B. Tauris, 1993), 1–22, esp. 4.

4 Albert Hourani, *A History*, 75–9, 253–6, 299–312.

5 Edward Said, *Orientalism* (New York: Vintage Books, 1979).

SECTION 2
IDEAS

MAIN IDEAS

KEY POINTS

- The core themes of the text are the continued development and growth of Arab society, the cultural and intellectual diversity of the Arab world, and the significance of the Arab cultural forms and social structures that had lasted over time.

- Hourani refutes Western scholarship that says the Arab civilization declined between 1000 and 1800. He claims it adapted to external influences.

- He uses balanced language to persuade readers of his point of view.

Key Themes

Three overarching themes run though Albert Hourani's *A History of the Arab Peoples*:

- The intellectual and cultural vitality of Arab societies throughout their history.

- The diversity of the Arab world, which is nonetheless unified through the Arabic language.

- The significance and persistence of cultural and social continuity in the Arab world.

The book is meant to be a narrative history of the Arab peoples and does not explicitly state its themes. They emerge as the book progresses.

It's important to understand that these themes support one of

> 66 Hourani is one of the few scholars capable of writing a worthwhile history of the Arabs from the rise of Islam until the present day in under 600 pages. His treatment is inevitably broad-brush, but never superficial. He covers not only political history but culture, society, economy, and thought; and this distillation of a lifetime's scholarship is the book's greatest virtue. 99
>
> *The Economist*

Hourani's aims in writing the book. The discipline of Middle Eastern Studies had developed during Hourani's lifetime; indeed, he was one of the people who had helped to create it. So, on one level, he wrote *A History of the Arab Peoples* to validate the discipline and show that it was worthy of study. Hourani achieved that in a number of ways:

- Demonstrating that the Arab peoples could be seen as a cohesive group.

- Showing that the history of the Arab peoples was complex and that the Arabs shaped their own societies.

- Revealing the richness of sources that could be used to study the people of the Middle East.

- Tracing the aspects of Arab society that had lasted through time, one benefit of which was to show that history could shed valuable light on the present.

Exploring the Ideas

The first major theme that Hourani addresses in *A History of the Arab Peoples* is the ongoing intellectual and cultural vitality of Arab societies throughout their history. Hourani refutes the persistent idea among

Western scholars that the Arab world had undergone a centuries-long period of stagnation and decline between 1000 and 1800. That was the period during which the Ottoman Empire* seized political control of the Middle East.

One of the ways Hourani counters the idea of Arab decline is by devoting a substantial section of his book to this period, rather than skipping over it as unimportant. He acknowledges the persistence of the idea of decline before succinctly telling the reader that it "is a difficult one to use ... [It] might be more correct to say that what had occurred was an adjustment in Ottoman methods of rule."[1]

The second major theme in the text is the diversity within the Arab world. Again, readers must understand this theme as Hourani pushing back against another persistent idea: that a single powerful civilization that was resistant to change—the original Arab culture of the Hijaz,* where Islam originated—dominated the region. Hourani acknowledges that this culture was significant, even using it as the starting point for the book. However, he goes on to emphasize the multiple groups that gradually fed into the Arab Muslim world:

- The Egyptians, Mesopotamians, and Persians from the ancient empires of Western Asia.

- The Greeks and Romans, in particular from the Eastern Roman Empire in Byzantium, which occupied much of the Middle East.

- The Turkish peoples, especially from the Ottoman Empire.*

- The Europeans.

The third major theme is the significance of cultural forms and social structures which persist over the longue durée,* a long period of time. Hourani understood historical change in terms of the "two interlocking rhythms of change." Those rhythms are, on the one hand, change that forces external to a particular society produced, and, on

the other, change that "a great stable society with a long and continuous tradition of life and thought was producing from within itself." The latter process of change also reveals many continuities over time. Hourani argues that key aspects of Arab society—notably the culture of the religious and cultural elite—developed in this slow, incremental way, building on the ideas and achievements of the past. For Hourani, these slowly changing aspects of Arab society linked the generations together.[2] Hourani returns to this idea throughout the book.[3]

Language and Expression

The purpose of *A History of the Arab Peoples* was to provide readers with a comprehensive history of the Arab world, written in language that was accessible to a broad audience. Hourani weaves a wealth of research into the text, while writing in an elegant, easy-to-read style.

In the book, Hourani addresses issues that the Palestinian-American scholar Edward Said* raised. The American-Israeli political scientist Martin Kramer* had described Said's arguments against the scholarship of the Orientalists,* voiced in his 1978 book Orientalism, as "hysterical." Yet even while making broadly similar points to Said, Hourani's language is balanced. He actively avoids contentious debate. This is most obvious in the way that, rather than discussing political division among the Arab peoples, he focuses on social unity.

But this approach can make it difficult to critically assess Hourani's work. Written as a narrative, *A History of the Arab Peoples* lacks an explicitly stated core argument. Rather than put forward a theory, Hourani persuades his readers to share his point of view by building up multiple examples of behavior or activities. Such behaviors or activities support his idea of the vitality of Arab society and the ways in which it can be viewed as cohesive. For readers who don't have any prior knowledge of Arab history, it is hard to see whether anything has been omitted from the text or what the counter-arguments to Hourani's views might be.

NOTES

1 Albert Hourani, *A History of the Arab Peoples*, 3rd ed. (London: Faber and Faber, 2013), 249–50.

2 Hourani, *A History*, 128.

3 Hourani, *A History*, 1–4, 457–58.

MODULE 6
SECONDARY IDEAS

KEY POINTS

- Hourani explores the diversity of the Arab world by looking at the different groups within it, contrasting rich and poor, settled and nomadic, male and female.
- He shows that commonly understood ideas helped to bond together different sections of Arab society.
- Hourani believed that it was possible for a historian to have an objective understanding of the past.

Other Ideas

Albert Hourani's main objective in writing *A History of the Arab Peoples* was to provide "a history of the Arabic-speaking parts of the Islamic world, from the rise of Islam until the present day."[1] He was interested in the lived experience of the Arab peoples: how individual members of a society went about their daily lives. He studies this as closely as he can, looking at a wide range of groups: urban, rural, rich, poor, male, female, religious, secular. Wherever possible, he explores how the experience of these groups have evolved over time.

By examining the daily life and ordinary experiences of different groups within Arab society, Hourani hopes to reveal the diversity of that society. He uses a wide range of sources to provide these insights: the operation and regulation of markets, the taxation and control of the countryside, the significance of architecture and urban design. These elements shaped people's lives and helped to regulate social interaction among the different groups. By looking at how they changed over time, Hourani is able to draw conclusions about how Arab civilization developed and the relationships among different sections of its society.

> ❝ No brief review can do justice to its many threads: cities and countryside, peasants and Bedouin, ulama and Sufi saints, imperialism and nationalism, urbanization and population growth, women and men, music and architecture, education and religion. ❞
>
> Donald Malcolm Reid, *The International History Review*

Exploring the Ideas

Perhaps the most notable relationship that Hourani examines in *A History of the Arab Peoples* is the one between urban and rural life. Hourani draws attention to the variety of environments in which the Arab peoples lived—from mountainous to desert, grassland to fertile valleys, country to city.

The people who lived in these different environments had very different lives. Nonetheless, Hourani shows how these groups affected one another and operated within a common social structure. For example, he describes how ideas about political authority, devised by the urban elite, were used to control rural populations. The intellectual elite argued that a ruler did not rule by virtue of strength alone. They set out a framework for establishing who was a legitimate ruler and within what limits he should be obeyed. This framework created a social contract between the ruler and the ruled. As a result, a ruler could demand obedience as a right. Ruling dynasties used these ideas to control rural populations and to prevent nomads and tribesmen from disrupting the established political and economic order.[2]

A secondary theme that Hourani returns to throughout his text is how Arabs consistently adapted to foreign influences and used those experiences to their advantage. For example, Hourani shows that during the years when the Ottoman Empire* ruled many Arab provinces, Arab societies adapted many Ottoman structures and values and integrated them into their own society. The Turkish heartland of

the Empire became a market for Syrian textiles. Mosques were decorated using tiles designed in the Ottoman Iznik style. Populations mingled and intermarried. The picture Hourani paints contrasted sharply with previous works that had argued that Arab nationalism* developed as an antagonistic response to Ottoman rule.[3]

Hourani describes how this ability to adapt to foreign ideas was also evident in the Arab experience during the colonial* period. By using European notions of nationalism and freedom, the peoples of the Middle East brought about the process of decolonization*— gaining national independence from European powers—earlier than it occurred in other regions in the world.

Overlooked

Few, if any, major aspects of *A History of the Arab Peoples* have been overlooked in terms of its major conclusions. The text is too well known and has been too influential for that to be the case. Due to the style in which it is written, the book's underlying methodological approach is not immediately obvious. However, because Hourani's way of working was closely related to other developments in the field and to the work of his contemporaries, it doesn't offer new ground for study.

The one major aspect of Hourani's thought that does stand somewhat aside from general trends, however, is his approach to epistemology,* the study of knowledge itself. Postmodernist* scholars, who became influential in the late twentieth century, tended to be skeptical of the idea that the past could be understood as having a totally objective reality that could simply be investigated and then "packaged up" by historians. However, Hourani retained an optimistic belief in the existence of an objective truth for which scholars could strive. That was partly due to his strong religious convictions and also because he developed as a scholar before the full impact of postmodernism* was felt in the humanities.

Hourani openly admitted to his difficulty in overcoming personal biases and limitations. However, he thought that the historian can refine a true appreciation of those separated from him or her by time and space. "Is it possible to grasp the essential nature of a country other than one's own? Yes, in the sense in which one can know a human being other than oneself: through patience, clarity, and love, and with a final acceptance of the mystery of otherness."[4]

NOTES

1 Albert Hourani, *A History of the Arab Peoples*, 3rd ed. (London: Faber and Faber, 2013), xiii.

2 Hourani, *A History*, 136–47.

3 Hourani, *A History*, 207.

4 Albert Hourani, preface to Jacques Berque, *Egypt: Imperialism and Revolution*, trans. Jean Stewart (London: Faber, 1972).

MODULE 7
ACHIEVEMENT

KEY POINTS

- Hourani's socio-cultural approach to history allowed him to paint a more vivid picture of the Middle East than previous scholars had done.

- The 1991 publication date of A History of the Arab Peoples was key to its success. It came out during the Gulf War,* when interest in the Middle East was at a height.

- Hourani's work encouraged historians to look at history from a non-Western perspective.

Assessing the Argument

Albert Hourani's main objective when writing *A History of the Arab Peoples* was to provide "a history of the Arabic-speaking parts of the Islamic world, from the rise of Islam until the present day."[1] He uses a chronological structure in the book, with his closing chapters dealing with the Arab world in the aftermath of the Six-Day War* of 1967. This conflict between Israel and the combined forces of Egypt, Syria, and Jordan saw a comprehensive Israeli victory and shifted the balance of power in the Middle East.

Hourani acknowledges in the book that tension over faith had become the guiding force in the Middle East in the late twentieth century. This shows impressive foresight, given that the book appeared a full 10 years before the 2001 attacks on New York.* That said, the last words of the book suggest Hourani believes that this may not always be the case. "It might happen too, that, at a certain stage of national development, the appeal of religious ideas—at least of ideas sanctified by the cumulative tradition—would cease to have the same force as another system of ideas: a blend of social morality and law

> **❝** Distilling a lifetime of studies on the subject, *[A History of the Arab Peoples]* won great acclaim and, appearing in the wake of the Persian Gulf war* against Iraq, promptly reached the best-seller lists and stayed on them for many weeks. **❞**
> Wolfgang Saxon, *New York Times*

which were basically secular, but might have some relationship to general principles of social justice inherent in the Qur'an."

Yet despite his chronological structure, Hourani wanted to avoid a simple political history of the Middle East.[2] He intended to give an overview of the social, economic, intellectual, and cultural dimensions of Arab societies and explore how they developed over time. The work does not follow the "great men" style of history. It has relatively little to say about the major political and military leaders that dominate other histories of the Middle East. Instead, Hourani's socio-cultural approach allows him to paint a much more vivid picture of the Middle East than previous analyses of this subject had. In this, he was successful in achieving his objective.

Achievement in Context

Hourani's text was published at a time when both the region and the entire international system were in the midst of a major upheaval. The success of the 1978–9 Iranian Revolution* fueled internal tensions in the Middle East.

The new Shi'a government of Iran stated its intention to export its revolution throughout the region in hopes of overthrowing the conservative, Sunni*-dominated monarchies of Saudi Arabia, Jordan, and the Gulf States. These tensions eventually culminated in the outbreak of the brutal, eight-year-long Iran-Iraq War* in 1980. Sectarian groups in Lebanon* and Syria* fought among themselves.

And in 1987, the Intifada* saw a Palestinian rebellion against the ongoing Israeli occupation.

With the end of the Cold War,* the global international situation was also going through a profound change. Throughout 1989, Eastern Europe was liberated from communist* rule, culminating in the fall of the Berlin Wall* in November of that year. These radical transformations of the European and international orders could easily have eclipsed the impact of *A History of the Arab Peoples*.

However, in August 1990, Iraq invaded Kuwait. Hourani's book came out a few months later, in January 1991. On January 17, the American-led Operation Desert Storm began. This military action forcefully ejected the invading Iraqi forces from Kuwait on February 28. Without question, these events—known as the Gulf War*— magnified the importance of Hourani's text. Interest in the Arab world increased, not only among students and the general public, but also among military leaders and policy makers.

One indication of the book's success was its appearance on the New York Times nonfiction bestseller list. *A History of the Arab Peoples* was subsequently translated into French, German, and Japanese. It has been reissued twice since its original publication, once in 2002 and again in 2012.

Limitations

Hourani's objective in writing *A History of the Arab Peoples* was to open the subject to a wider academic and general audience. It achieved these aims. To date, no publications have surpassed *A History of the Arab Peoples* as a scholarly overview of the topic over such a broad sweep of time. It remains a key introductory text.

In Hourani's immediate field of Middle Eastern Studies, his multidisciplinary approach to researching the book encouraged historians to take a broader methodological view of their subject. In the wider academic sphere, Hourani's work helped to change the way

history is written. He championed a new approach that was less centralized and less narrowly focused on Western perspectives. As one assessment put it, Hourani's work has "encouraged an otherwise all too painfully slow acceptance in Western ethnocentric academia of the importance of studying human experiences beyond their own."[3] *A History of the Arab Peoples* fed into the development of international history* in that scholars applied Hourani's approach to other civilizations, like the Islamic or Chinese civilizations.[4]

Yet Hourani's methodology had limitations. It applied only to particular disciplines: Area Studies* or Civilizational Studies. The book's success meant that Hourani, whom everybody saw as a modest and unassuming man, achieved more than he probably expected.

NOTES

1 Albert Hourani, *A History of the Arab Peoples*, 3rd ed. (London: Faber and Faber, 2013), xiii.

2 Hourani, *A History*, 212.

3 John Spagnolo, "Albert Hourani: an Appreciation," *Problems of the Modern Middle East in Historical Perspective: Essays in Honour of Albert Hourani*, ed. John Spagnolo (Reading: Ithaca Press, 1996), 1.

4 Seyyed Hossein Nasr, *Islam: Religion, History, and Civilization* (London: HarperOne, 2002); Firas Alkhateeb, *Lost Islamic History: Reclaiming Muslim Civilization from the Past* (New York: Hurst Publishers, 2014); and Xingpei Yuan and Wenming Yan, *The History of Chinese Civilization* (Cambridge: Cambridge University Press, 2012).

PLACE IN THE AUTHOR'S WORK

KEY POINTS

- Throughout Hourani's life his research focused on the social, cultural and political history of the Middle East and the Arab peoples.

- Published in 1991 just prior to Hourani's death, *A History of the Arab Peoples* was the culmination of a lifetime of study and research on the Middle East.

- A History of the Arab Peoples was Hourani's most successful book and his swansong. But his earlier works were also widely respected contributions to the field of Middle Eastern Studies.

Positioning

Albert Hourani's *A History of the Arab Peoples* was the culmination of a lifetime of research and scholarship. It reflected his deep interest in the intellectual, social, and cultural history of the Middle East.

Hourani's earlier works focused mostly on the modern era in the Middle East. They were largely political texts, aimed at informing political policy makers, and he wrote them while he was still attached to the Foreign Office. His first major publication was Syria and Lebanon: A Political Essay, written in 1946 for Chatham House (the Royal Society for International Affairs), a London-based foreign policy think tank. In the text, Hourani examined how the Middle East had been affected by the impact of European power and European ideas. He used the experience of Syria and Lebanon to illustrate the tremendous impact Western involvement has had on modern Arab society.[1]

Hourani's next text, Minorities in the Arab World, was published in

> 66 Albert Hourani was a leading historian of
> the Middle East. As both teacher and author, he
> illuminated the development of Arab nationalism and
> the long and often troubled relationship between
> Islam and the West. 99
>
> Roger Hardy, "Obituary: Albert Hourani," *The Independent*

1947. In that work, he examined the troubled history of minorities throughout the region, concluding that—despite efforts to pass laws to protect them and the repeated protestations of Arab rulers—their position would always be "precarious."[2]

In 1962, Hourani's writing took a different direction. He published Arabic Thought in the Liberal Age, 1789–1939, which looked at the work and writings of key Arab political thinkers.[3] His first direct foray into social, intellectual, and cultural history, this text served as the intellectual forerunner of his 1991 *A History of the Arab Peoples*.

Hourani's final work, published in 1992, was a collection of essays, Islam in European Thought. Here he addressed the question of how European scholars had tried to understand Islam and Islamic societies. The essays further explored one of the major questions of *A History of the Arab Peoples*: how the societies of the Middle East had responded to European events and ideas.

Integration

A History of the Arab Peoples should be viewed as consistent with Hourani's main intellectual concerns: to understand Middle Eastern history on its own terms and to explain it in a way that could be broadly understood by readers in the English-speaking world. From this perspective, his work has been incredibly successful. Reviewers

have hailed every one of his major publications.[4]

Because Hourani wrote exclusively about the Middle East, his work has an overall coherence and logical thrust. Within the region, he was initially concerned with the Levant*—historical Lebanon, Syria, and Palestine—and, to a lesser extent, Egypt. *A History of the Arab Peoples* therefore represents something of a new direction in Hourani's work by going considerably beyond his areas of specialization, both geographically and chronologically, though, conceptually speaking, the text is linked to his previous work. It emphasizes changes in Arab society and how this society responded to outside influences. However, it also takes account of the continuities within the Arab world and the persistence of traditional cultural forms and social structures.[5]

Hourani's later texts (Arabic Thought in the Liberal Age, 1789–1939; *A History of the Arab Peoples*; and Islam in European Thought) reflected his deep interest in intellectual history. In *A History of the Arab Peoples*, he examines the ideas that helped to shape Arab society, showing how the crucial period of modernization

Significance

Due to its popular success and impact on a wide audience, *A History of the Arab Peoples* is Hourani's most influential work. Its publication date played a key part in this. In the aftermath of the 1990–1 Gulf War,* the English-speaking world was obsessed with the Middle East. Instead of offering a traditional political history of rulers and regimes, Hourani provides a much more nuanced—and helpful—description of the Arab world and its culture. Quite rarely for an academic text, *A History of the Arab Peoples* immediately became a commercial success and stayed on the "best seller" list for many weeks.[6]

Hourani never intended *A History of the Arab Peoples* to be a seminal text that established a new school of thought or offered a new theoretical model for the study of history. Indeed, he "judiciously

sidestepped" controversial issues. He avoided engaging in academic debates and focused on what unified the region, rather than the issues that divided it. His approach conveyed the rich cultural, social, and intellectual history of the Arab people.

The text remains one of the most significant studies of Arab history, society, and culture. Similarly, Hourani continues to be considered one of the foremost scholars of the Middle East. This is partly due to the success of *A History of the Arab Peoples*, but it's also because of Hourani's influential teaching role at the University of Oxford, where he trained a generation of students from Britain, the United States and the Middle East. Hourani also played a key role in the establishment of the British Society for Middle Eastern Studies (BRISMES) and served as its first president. In short, "Hourani was for two decades … Middle East Studies, personified."[7]

NOTES

1 Albert Hourani, *Syria and Lebanon: A Political Essay* (London: Oxford University Press, 1946).

2 Albert Hourani, *Minorities in the Arab World* (London: Oxford University Press, 1947), 21.

3 Albert Hourani, *Arabic Thought in the Liberal Age* (London: Oxford University Press, 1962).

4 See M. S. C., "*Syria and Lebanon, A Political Essay* by A. H. Hourani," *World Affairs* 109/4 (1946): 302; C. D. Quilliam, "Review: *Minorities in the Arab World* by A. H. Hourani," *International Affairs* 24/1 (1948): 138; L. E. Goodman, "Arabic Thought in the Liberal Age, 1798–1939," *The International History Review* 8/1 (1986): 107–11; and D. O. Morgan, "Review: *Islam in European Thought* by Albert Hourani," *Journal of Royal Asiatic Society* 2/2 (1992): 261.

5 Albert Hourani, "How Should We Write the History of the Middle East," *International Journal of Middle East Studies* 23 (1991): 125–36, esp. 128.

6 Wolfgang Saxon, "Albert Hourani, 77, Acclaimed Mideast Scholar," *New York Times*, January 21, 1993.

7 P. J. Vatikiotis, "Albert Hourani: In Memoriam," *Middle Eastern Studies* 29/2

SECTION 3
IMPACT

THE FIRST RESPONSES

KEY POINTS

- The main criticisms of *A History of the Arab Peoples* are Hourani's disproportionate focus on the Ottoman period, his tendency to avoid controversy, an uneven use of the available scholarship, and his lack of an identifiable argument or conclusion.

- Because Hourani died shortly after the publication of the text, he was unable to respond directly to his critics.

- The most important factor shaping the reception of the text was Hourani's established role as a leading scholar of the Middle East.

Criticism

The overall response to Albert Hourani's *A History of the Arab Peoples* was positive, but there was some criticism. The most common one was that Hourani focused too much on the Ottoman* period. The American scholar Donald Malcolm Reid* noted that 43 percent of the text was devoted to the Ottoman period in the nineteenth and twentieth centuries, whereas only 44 percent dealt with the nine centuries that came before it.[1] The American historians C. Ernest Dawn* and L. Carl Brown* commented on the same thing.[2]

Some academics believe that a text cannot be seminal—or fundamental to the study of a discipline—unless it addresses the core debates of the issue at hand. Hourani did not do this in *A History of the Arab Peoples*. Reid found that Hourani sidestepped the contentious debate about the Prophet Muhammad's* life.[3] Dawn thought his discussion of the roots of Arab nationalism* was "troublesome,"

❧ In style and sweep, *A History of the Arab Peoples* is a
virtuoso performance. Hourani is freer on the smaller
canvas of the essay, more fluent in his previous writings
on the European understanding of the Arabs than on
the Arabs themselves. Still, elegance and erudition
remain his hallmark, and both are evident in this book.
So, too, is his debt to the wealth of Western scholarship:
Hourani has drawn upon its deepest traditions and has
carefully distanced himself from the hysterical anti-
Orientalism* first propagated by Edward Said.*❧

Martin Kramer, "Sandbox"

noting that his "exposition follows some common notions that rest on
fragile foundations."[4] The Palestinian-Lebanese American historian
Rashid Khalidi* said that the work did not deal with the history of
the pre-Islamic Christian Arabs. Critics argued that Hourani had
framed Arab history a little too closely to Islamic history. They also
pointed out that he had devoted less attention to important regions,
notably the Hijaz,* the Yemen, and the Maghrib* (the western portion
of Arabic-speaking North Africa), while focusing disproportionately
on the Levant* and Egypt.[5]

The Syrian historian Aziz al-Azmeh,* one of Hourani's former
students, argued that the scope of the text resulted in "some unevenness
in the use of recent scholarship." For instance, Azmeh commented
that "the entire history of the earliest period of Islam has been subject
to severe historical critique, but [Hourani] elected to restate the
traditional picture, presumably because the criticism has so far been
negative and no positive picture has yet emerged."[6]

Finally, one of the most problematic aspects of the text is its lack of
a clear conclusion. As Brown observed in the *New York Times*, "The
book lacks a real conclusion, a summing up of the 14 centuries

covered. Yet, on balance, such is the Hourani style. His is not a history that presents a grand design, an unfolding of God's or Nature's plan."[7]

Despite these criticisms, Hourani was generally regarded as having achieved an admirable fusion of an impressive range of scholarship. Indeed, every review of *A History of the Arab Peoples* was quick to praise the text and Hourani's scholarship.

Responses

Hourani died in January of 1993, less than two years after the publication of *A History of the Arab Peoples*. It's sad that he was not able to respond to these criticisms, and it would have been interesting to see if he would have modified his positions as time went on.

Hourani had a widespread reputation as a fair-minded scholar prepared to consider different points of view. Around the time of *A History of the Arab Peoples*, he also published several shorter essays. In those essays, he admitted to the possible limitations of his approach.[8] He was receptive to the idea that Arab civilization in itself was a problematic unit of analysis and sympathetic to the argument that the Arab world should be analyzed within the framework of the wider Islamic civilization.[9] He had some doubts about the extent to which all the Arabic-speaking regions could really be compared, and he feared that he might not have analysed them all evenly. Hourani also accepted that with a scope as wide as *A History of the Arab Peoples*, he was bound to have made mistakes on some specific specialist points. He was prepared to accept criticisms on that basis.

Overall, however, Hourani was strongly committed to the fundamental arguments of his book. *A History of the Arab Peoples* was the product of a long period of work, and Hourani regarded it as a final summing up of his thinking.[10] Given this, it seems unlikely that he would have radically changed his opinions even if he had lived longer.

Conflict and Consensus

Because Hourani died shortly after the publication of *A History of the Arab Peoples*, he had no opportunity to alter his views. At the same time, none of the criticisms leveled at the book undermined the text's overall value. In fact, reviewers were overwhelming in their praise of Hourani's scholarship. The fact that the book wasn't written to spark discussion, or to engage in issues that would cause major disagreements, has also limited debate over it.

The text's overall value stems from its continued role as an indispensable work of reference and the way it created a framework for studying the Middle East. It is among the foundational texts of the discipline of Middle Eastern Studies and serves as an important point of departure for its ongoing evolution.

Hourani helped to shape the field when it first evolved. He wrote *A History of the Arab Peoples* at a time when the first generation of Middle Eastern scholars were passing the torch on to their students. In this book, he was summing up his knowledge of the region and passing it on to the scholars who were to come after him. In the years since its publication, a new generation of Middle Eastern scholars have read the text, absorbed it, and used its ideas to inform their own thinking. This process has sustained the text's importance as a seminal piece of scholarship.

NOTES

1 Donald Malcolm Reid, "Review: *A History of the Arab Peoples* by Albert Hourani," *The International Historical Review* 14/2 (1992): 347.

2 C. Ernest Dawn, "Review: *A History of the Arab Peoples* by Albert Hourani," *The American Historical Review* 97/2 (1992): 589; and L. Carl Brown, Review: "Empires in the Sand: *A History of the Arab Peoples* by Albert Hourani," *New York Times*, March 31, 1991.

3 Reid, "Review," 348.

4 Dawn, "Review," 589.

5 Rashid Khalidi, "Arab Nationalism: Historical Problems in the Literature," *American Historical Review* 95/1 (1991): 1365.

6 Aziz al-Azmeh, "Review: *A History of the Arab Peoples* by Albert Hourani," *History Workshop Journal* 40/1 (1995): 250.

7 Brown, "Empires in the Sand."

8 Albert Hourani, "How Should We Write the History of the Middle East," *International Journal of Middle East Studies* 23/1 (1991): 125–36.

9 Albert Hourani, introduction to *The Modern Middle East: A Reader*, Albert Hourani, Philip S. Khoury, and Mary C. Wilson, eds. (London and New York: I. B. Tauris, 1993), 1–22.

10 Albert Hourani, "Patterns of the Past," *Paths to the Middle East: Ten Scholars Look Back*, ed.Thomas Naff (Albany: SUNY Press, 1993), 27–56.

MODULE 10
THE EVOLVING DEBATE

KEY POINTS

- Even though *A History of the Arab Peoples* was never intended to be a groundbreaking study, it has been influential as a leading model for future Area,* Middle Eastern, and Civilizational Studies.

- While no specific school of thought formed around *A History of the Arab Peoples* or Hourani, the text has nonetheless influenced many scholars in the field of Middle Eastern Studies.

- Former students, and in turn the students they have taught, have developed Hourani's approach and ideas.

Uses and Problems

Albert Hourani's *A History of the Arab Peoples* did not introduce any radical revisions to the story of Arab history. Instead, it presented a mix of Hourani's own research along with the work of other historians across a very wide field of inquiry. Yet this synthesis became intellectually significant in its own right because the book was written at a key moment in the history of Middle Eastern Studies as a discipline.

Middle Eastern Studies had been developing from the 1950s onwards, a process that accelerated after Edward Said* criticized its predecessor, Oriental Studies,* in 1978. By 1991, Hourani's generation had laid the groundwork for Middle Eastern Studies, and the field had consolidated as an academic discipline both intellectually and institutionally. At that point, a new generation of scholars was emerging to advance it further.[1] Hourani's text summed up his thinking and findings, as well as those of his contemporaries, and acted

> **❝** There is nothing remotely comparable to this sweeping and masterful synthesis ... Although intended for 'general readers' and 'students who are beginning to study the subject,' *A History of the Arab Peoples* is a work that every specialist in the field should also find richly rewarding. **❞**
>
> Donald Malcolm Reid, *The International History Review*

as a foundation for this new generation.

As a result, *A History of the Arab Peoples* became a compelling and influential framework for the field of Middle Eastern Studies. It opened up a range of important debates. Was unity or division more important in Arab history? What is the relationship between the political history of the Arab world and its social, intellectual and cultural histories? Which sources are the most important in the study of Arab history: sources created within Arab societies or external sources?

Hourani's work suggested ways of studying the Middle East and defined geographical and chronological boundaries for that study. His text was not so much a "game-changer," as it was a book of rules and tactics for the game itself.

Schools Of Thought

Hourani's influence as both a writer and an academic has been far-reaching. While *A History of the Arab Peoples* didn't inspire (or set out to inspire) a specific school of thought, it did help to define Middle Eastern Studies as a mature field of study, establishing the essentials of the discipline:

- An emphasis on the internal sources of Middle Eastern societies.

- Prioritizing the analysis of the inner structures and forms of those societies, for example, the elite religious groups.

- Acknowledging the evolution of those structures and forms.

- Using multidisciplinary approaches to explore the past.

- Siting Middle Eastern history in a wider framework and linking it to neighbouring civilizations and human history as a whole.

The "rules" helped define the core of Middle Eastern Studies. They also provided a methodology that was helpful for scholars interested in a nuanced approach to the study of civilizations, one that looked beyond politics.

Hourani's influence continues to be felt among scholars of Middle Eastern history. This is particularly true of those who want to emphasize the links between the Middle East and the wider world and who consider those links to be equally as important as the distinctive aspects of Middle East society. This is better described as an academic position than a specific school of thought.

In Current Scholarship

Hourani was widely admired as an inspirational teacher and mentor. His influence on the training and development of a whole generation of scholars in his field was made easier because of the work he did for many years at the Middle East Centre at the University of Oxford. A number of important of scholars can be identified as heirs to his work and approach.

Among Hourani's students who have made important contributions to the field and reflect his influence are:

- Palestinian–Lebanese historian Rashid Khalidi.* His impressive work on Arab and Palestinian nationalism explores the concept of Palestinian national identity. Like Hourani, he looks at this

issue over an extended time frame.

- British historian and anthropologist Michael Gilsenan.* His early scholarship about Egyptian sufis (mystics) reflects Hourani's interest in the way societies adapt as a result of external influences.

- British historian Peter Sluglett.* As Hourani did elsewhere in the Middle East, Sluglett analyzes the way local structures in Iraq were affected by, and adapted to, European influence.[2]

Other scholars who did not study directly under Hourani but who can be seen as working in his tradition are: the Turkish historian Halil Inalcik,* who has spearheaded the use of Turkish sources in the study of Ottoman* history; Suraiya Faroqhi,* a leading German historian of Ottoman economic and urban history; and Leila Fawaz,* a Lebanese social historian, who, like Hourani, specializes in the Arab Ottoman provinces.[3] The work of all of these scholars reflects Hourani's example in focusing closely on the social and economic structures underpinning processes of historical change.

NOTES

1 Albert Hourani, "Patterns of the Past," *Paths to the Middle East: Ten Scholars Look Back*, ed. Thomas Naff (Albany: SUNY Press, 1993), 53.

2 Rashid Khalidi, *British Policy towards Syria and Palestine, 1906–1914* (Ithaca, NY: Ithaca University Press, 1980); Khalidi, *Palestinian Identity: The Construction of Modern National Consciousness* (New York: Columbia University Press, 1997); Michael Gilsenan, *Saint and Sufi in Modern Egypt: An Essay in the Sociology of Religion* (Oxford, UK: Clarendon Press, 1973); Peter Sluglett, *Britain in Iraq: Contriving King and Country* (New York: Columbia University Press, 2007); and Peter Sluglett and Marion Farouk-Sluglett, *Iraq Since 1958: From Revolution to Dictatorship* (London: I. B. Tauris, 2001).

3 Halil Inalcik, *The Ottoman Empire: The Classical Age 1300–1600* (New Haven, CT: Phoenix Press, 2001); Suraiya Faroqhi, *Subjects of the Sultan: Culture and Daily Life in the Ottoman Empire* (London: I. B. Tauris, 2005);

MODULE 11
IMPACT AND INFLUENCE TODAY

KEY POINTS

- Despite the major events that have occurred in the Middle East since the publication of *A History of the Arab Peoples*, the book remains an influential text.

- Hourani's views are still a reference point in the debate about Arab unity,* whether it exists and, if so, to what degree.

- His views are a counterpoint to the arguments of prominent intellectuals like Bernard Lewis* and Samuel Huntington,* who claim the Arab world is fundamentally at odds with the West.

Position

Today, Albert Hourani's *A History of the Arab Peoples* remains a highly respected work. More than 20 years after its publication universities continue to use it as a standard textbook to introduce undergraduates to the field of Middle Eastern Studies.

Hourani did not see his work as definitive though. He argued that political and social change worldwide would mean that his students and colleagues would need to start asking new questions about the region. He believed these new questions would also require new methods of historical research.[1]

Since the publication of the book, many changes have occurred. Following the Gulf War* of 1990–91, the United States has taken on an increasingly visible role in Middle Eastern politics. That involvement intensified following September 11, 2001 (9/11),* when the Islamist group al-Qaida* killed almost 3,000 people in the United States. A number of dramatic internal changes have also occurred within the

> ❝ This is no less than a clash of civilizations—the perhaps irrational but surely historic reaction of an ancient rival against our Judeo-Christian heritage, our secular present, and the worldwide expansion of both. It is crucially important that we on our side should not be provoked into an equally historic but also equally irrational reaction against that rival. ❞
>
> Bernard Lewis, "The Roots of Muslim Rage"

Arab world, including the wave of popular uprisings and revolutions known as the Arab Spring.*

Yet despite those changes, Hourani's approach to the history of the Middle East remains attractive. His multidisciplinary methodology, his deep respect for Arab perspectives, and his belief in the value of Western scholarship about the Arab Muslim world continue to offer a sound foundation for historical inquiry.

Interaction

Two aspects of *A History of the Arab Peoples* continue to be debated:

- To what degree are the Arab peoples unified?

- What is the true nature of the relationship between Arab societies and the wider world?

Hourani believed in the concept of Arab unity:* a fundamental and ongoing connection between all the Arab-speaking regions of the world but he also recognized that certain trends undermined this unity. In the final section of the book, he wrestles with the question of whether Arab unity might still exist in the post-independence period. In this sense, Hourani anticipates the continuing political fragmentation of the Arab world that has occurred since his death.

Yet while recognizing division amongst Arab societies in the book,

Hourani also offers an important analysis of the things he sees underpinning and unifying them. He argues that mass education and mass communications have strengthened two key, shared aspects of Arab life: the Arab language and the religion of Islam.[2] In turn, language and religion have helped spread shared culture and incite political actions. The Arab Spring,* a movement that started in 2010 and spread across part of the Arab world, has seemed to support these arguments.

A History of the Arab Peoples has also made a key contribution to the debate around the relationship between the Arab civilization and the rest of the world. In the text, Hourani was particularly critical of two concepts: 1) that Arab societies are essentially inflexible and unchanging, and 2) that Arab and Muslim civilization is fundamentally isolated from, and hostile toward, other civilizations.

While Hourani wanted to counter both these arguments in his book, they have gained renewed credibility since his death—to a small extent academically, but primarily in the public and the political arenas. Two prominent scholars, the historian Bernard Lewis* and the political scientist Samuel P. Huntington*, have both suggested that the Arab and Western civilizations are fundamentally incompatible. Their books, Lewis's *What Went Wrong?: Western Impact and Middle Eastern Response*,[3] and Huntington's *The Clash of Civilizations and the Remaking of the World Order*,[4] have both influenced policy makers, and policy has, in turn, affected public opinion.

While these debates are ongoing, Hourani's stature and scholarly credibility mean that *A History of the Arab Peoples* still makes an important contribution to the way people view the Arab world.

The Continuing Debate

Outside the field of Middle Eastern Studies, *A History of the Arab Peoples* remains an important text for nonspecialists by providing an overview of the subject. It situates Arab history within the context of

world history and remains influential in public and policy debates. For example, the United Nations Arab Human Development Reports of 2002–5 included Hourani's analysis of the Middle East.[5]

A number of public intellectuals, like Lewis* and Huntington,* have opposed Hourani's arguments in the wake of politically game-changing events in the Middle East—notably al-Qaida's* attack on the United States in September 2001 (9/11),* the Iraq War of 2003–2011,* the Arab Spring,* and the rise of the radical militant group Islamic State.* These intellectuals have reasserted their old viewpoints about the Arab world. They argue that Muslim societies have difficulty evolving and are built around a dominant and inflexible idea of Islam. These are concepts that Hourani's work wanted to challenge, and they have huge, real-world implications. Lewis and Huntington's ideas took center stage during the presidency of George W. Bush* when the United States started to take an increasingly visible role in Middle Eastern politics.[6] *A History of the Arab Peoples* remains a significant counterpoint to these viewpoints.

NOTES

1 Albert Hourani, "Patterns of the Past," *Paths to the Middle East: Ten Scholars Look Back*, ed. Thomas Naff (Albany: SUNY Press, 1993), 49–50.

2 Albert Hourani, *A History of the Arab Peoples*, 3rd ed. (London: Faber and Faber, 2013), 389–99.

3 Bernard Lewis, *What Went Wrong?: Western Impact and Middle Eastern Response* (London: Weidenfield & Nicholson, 2002).

4 Samuel Huntington, *The Clash of Civilizations and the Remaking of the World Order* (New York: Simon & Schuster, 1996).

5 Malise Ruthven, afterword in Albert Hourani, *A History of the Arab Peoples*, 3rd ed. (London: Faber and Faber, 2013), 459–502, esp. 484.

6 Ronald Inglehart and Pippa Norris, "The True Clash of Civilizations," *Foreign Policy,* November 4, 2009. http://foreignpolicy.com/2009/11/04/the-true-clash-of-civilizations/.

WHERE NEXT?

KEY POINTS

- Hourani focused on the Arab identity of the people of the Middle East, while more recent scholarship has tended to concentrate on the Islamic identity of the region.

- Hourani encouraged scholars of the Middle East to look at the social and economic structures that underpin historical change.

- *A History of the Arab Peoples* continues to challenge a range of negative thoughts and beliefs about the evolution and development of Arab society.

Potential

Albert Hourani's *A History of the Arab Peoples* will doubtlessly continue to be an influential social and cultural history of the Arab world. Its comprehensive approach has made it an invaluable reference point for scholars of the Middle East.

The text has become outdated in some ways, however. Hourani's point of focus in the book is the Arab peoples, but recent scholarship has concentrated much more closely on Islamic, rather than Arabic, identities. While Hourani presented Arab and Islamic history as intertwined, he also recognized that studies of political Islam had gradually surpassed studies of Arab history.

Since the early 1990s, research has focused on the rise of Islamic movements, like the radical Palestinian group Hamas,* the Shiite Muslim group Hezbollah,* the radical Sunni* Muslim organization al-Qaida,* and now the militant Islamic State.* This tendency increased following al-Quaeda's attacks on the United States in 2001,*

> 66 *A History of the Arab Peoples* is a scholarly account, not an apologia for the Arabs but a book written with just the right mix of empathy and sensitivity, and a feel for the irony of human history. This is history in the grand style. It can lead to a better understanding of the Arabs, past and present. 99
>
> L. Carl Brown, "Empires in the Sand"

during the 2003–11 Iraq War,* and in the course of the popular uprisings known as the Arab Spring* that began in 2010.*

Yet the rapid spread of the Arab Spring uprisings may offer some support to Hourani's ideas about the links between the societies of the Arab world. Modern methods of communication, notably social media, allowed people in the Arab world to communicate among themselves and with people in other Arab countries. That helped the uprising spread quickly across national boundaries. Hourani argued that language and Islam were key components to Arab unity. At least in its initial stages, the Arab Spring* raised the prospect of a return to an era of Arab unity* and Arab nationalism,* both central concepts that underpinned Hourani's work. If that happens, then it would further renew the impact of Hourani's work.

Future Directions

Thanks to Hourani's inspirational role as a founding scholar of the field of Middle East Studies, his work will continue to influence scholars into the future. Hourani trained hundreds of people, and his students will pass down the lessons he imparted to their own students. This means that a large number of scholars will continue to carry on the project he started many decades ago.

Among his notable students are the Palestinian-Lebanese historian Rashid Khalidi,* the British historian and anthropologist Michael

Gilsenan,* the British historian Peter Sluglett,* and the Syrian historian Aziz al-Azmeh.* All have made valuable contributions to the study of the Middle East.[1]

A number of scholars who did not study directly under Hourani also cite him as a primary influence—such as the Turkish historian Halil Inalcik,* the leading German historian Suraiya Faroqhi,* and the Lebanese social historian, Leila Fawaz.*[2] Like Hourani, these scholars focus closely on the social and economic structures that underpin processes of historical change.

In more general terms, Hourani's influence continues to be widely felt among scholars of Middle Eastern history. A recent and interesting example of this is *The Case for Islamo-Christian Civilization* by Richard Bulliet,*[3] a professor of history at Columbia University. This work offers a thought-provoking perspective about the similarities between Islam and Christianity, one with which Hourani himself surely would have sympathized.

Summary

Albert Hourani's *A History of the Arab Peoples* should be considered a seminal text first because of its scope, which covers the whole sweep of Arab history from the advent of Islam in the seventh century to the 1980s. Even more significant, it offered an eloquent and compelling restatement of how to understand the most fundamental questions of Arab and Muslim history. The book cleared away the persistent assumptions of earlier historians about the supposed decline of Arab civilization, emphasizing instead the continued cultural and intellectual evolution of Arab societies.

To do that, Hourani displayed an impressive command of a wide range of scholarship. He also used a methodological approach that remains close to definitive in the entire field of Middle Eastern Studies. It combined a sensitive reading and analysis of a wide range of source material, the study of how social structures developed, and a keen

appreciation for the role that the Arab civilization has played in the advance of human history.

Hourani was not alone in developing this approach, but the publication of *A History of the Arab Peoples* represented an important milestone in the maturation of Middle Eastern Studies.* It represented a kind of "taking stock" of the field's progress since the 1950s, while also offering a foundation for its ongoing evolution.

A History of the Arab Peoples remains among the best introductions to the subject for the general reader. Its accessibility has encouraged the integration of Middle Eastern history into other fields, such as Civilizational Studies.* Hourani was a scholar who could explain his subject in a relevant way in the public and policy-making arenas, and his work is still relevant in the many on-going debates about the Arab world, both in academia and far beyond.

NOTES

1 Rashid Khalidi, *British Policy towards Syria and Palestine, 1906–1914* (Ithaca, NY: Ithaca University Press, 1980); Khalidi, *Palestinian Identity: The Construction of Modern National Consciousness* (New York: Columbia University Press, 1997); Michael Gilsenan, *Saint and Sufi in Modern Egypt: An Essay in the Sociology of Religion* (Oxford: Clarendon Press, 1973); Peter Sluglett, *Britain in Iraq: Contriving King and Country* (New York: Columbia University Press, 2007); and Peter Sluglett and Marion Farouk-Sluglett, *Iraq Since 1958: From Revolution to Dictatorship* (London: I. B. Tauris, 2001).

2 Halil Inalcik, *The Ottoman Empire: The Classical Age 1300-1600* (New Haven, CT: Phoenix Press, 2001); Suraiya Faroqhi, *Subjects of the Sultan: Culture and Daily Life in the Ottoman Empire* (London: I. B. Tauris, 2005); and Leila Fawaz, *A Land of Aching Hearts: The Middle East in the Great War* (Cambridge, MA: Harvard University Press, 2014).

3 Richard W. Bulliet, *The Case for Islamo-Christian Civilization* (New York: Columbia University Press, 2004).

GLOSSARY

GLOSSARY OF TERMS

9/11: the hijacking of four passenger airliners in the United States by 19 individuals affiliated with the al-Qaeda terrorist organization. Two planes were flown into the World Trade Center towers in New York City and one into the Pentagon military headquarters in Washington, D.C. on September 11, 2001, resulting in significant loss of life.

Abbasid Empire: a dynasty of descendants of 'Abbas bin 'Abd al-Muttalib an uncle of the Prophet Muhammad, that ruled much of the Arab Muslim world from Baghdad between 750 and 1258 C.E.

Al-Nahda: an Arabic term meaning "the awakening" used to portray a movement of intellectual and cultural renewal among the Arabs— especially in Egypt Lebanon, and Syria—during the later nineteenth and early twentieth centuries.

Al-Qaida: a militant Islamic fundamentalist group that was behind a terrorist attack against the United States on September 11, 2001.

Annales School: an influential school of historical writing that emerged in France in the twentieth century from work first published in the journal *Annales d'Histoire Economique et Sociale* ("Journal of Economic and Social History"). It emphasized the analysis of history over very long periods and focused on social rather than diplomatic or political themes.

Arab Cold War (1952–70): a concept first coined by the Middle East specialist academic Malcolm Kerr (1931–86) and used to describe tensions between Arab nationalists states (such as Egypt, Syria, and Iraq) and the conservative monarchies (like Saudi Arabia, Jordan, and the Gulf States). The conflict ended in 1970 with the death of

Egyptian president, Gamal Abdel Nasser.

Arab nationalism: a nationalist ideology that emphasized the achievements of Arab civilization and encouraged the cultural renewal and political independence and union of Arab societies.

Arab Spring: a term used to describe a series of violent and non-violent protests, demonstrations, and civil wars that swept through the Arab world in 2010. As a result of the Arab Spring, rulers were forced from power in Tunisia, Egypt, Libya, and Yemen, although civil wars have erupted and are continuing in Syria and to a lesser extent, Bahrain.

Arab–Israel conflict: a period of tension between Israel and the Arab states (predominantly, Egypt, Syria, Jordan, and Iraq) that began when Israel was created in 1948. This resulted in a series of military conflicts in 1948, 1956, 1967, and 1973.

Area studies: the collective term for the interdisciplinary fields of scholarship relating to particular geographical and/or cultural regions.

Asabiyyah: an Arabic word that translates into the term "group loyalty" or "clannism" and that the medieval historian Ibn Khaldun used to describe the family, tribal, or other forces that keep a ruling group coherent enough to sustain its rule over the rest of society.

Berlin Wall: a heavily guarded wall that communist authorities built in 1961 between East and West Berlin to stop East Germans from entering the West. After the communist regime in East Germany collapsed in 1989, the wall was dismantled.

Caliphate: the chief ruler of the Muslim world, viewed as the Prophet

Muhammad's successor. The caliph ruled in Iraq and Egypt until the Ottoman conquest of 1517, when the Ottoman sultans adopted the title. It was abolished in 1924.

Camp David accords: an agreement signed between Egypt and Israel in 1978 that paved the way for an Egypt-Israel Peace Treaty after protracted negotiations at the United States' presidential retreat, Camp David, located in rural Maryland.

Cold War (1947–91): a period of tension between the United States and the Soviet Union. While the two blocs never had direct military conflict, they engaged in covert wars and espionage against one another.

Communism: a theory advocating a society where there should be no private ownership, all property being community-owned and labor organized for the common benefit of all members. The principle of communism is that each person should work according to his capacity and receive according to his needs.

Epistemology: the investigation of what distinguishes justified belief from mere opinion.

Global history: see World History.

Globalization: the process by which the world seems to become increasingly smaller. This is often the result of advances in communication and growing interactions of culture, commerce, religion, and politics among groups that normally would not have been in contact with one another.

Greek Orthodox Christianity: a branch of Christianity within the

wider communion of Eastern Orthodox Christianity.

Gulf War: regional war between the coalition forces (led by the United States) and Iraq. The conflict was sparked by the invasion of neighboring Kuwait by Iraqi forces.

Hellenism: the adoption of elements of Greek language, culture, and philosophy in the ancient world.

Hijaz: the region in present-day Saudi Arabia that contains Mecca and Medina, the two holy cities of Islam, where the religion began.

Historiography: the study of how a historical debate evolves over time.

Iran–Iraq War (1980–88): a major military conflict between Iran and Iraq that began when Iraq invaded Iran in September 1980 and came to an end in 1988, when Iraq scored a decisive victory.

Iranian Revolution (1979): revolt that ousted Western-backed Shah Mohammad Reza Pahlavi (the ruler of Iran at the time) and saw the establishment of an Islamic Republic led by Shi'a religious leader Ayatollah Ruhollah Khomeini.

Iraq Revolution (1958): an uprising on July 14, 1958 when a group of Arab nationalist military officers overthrew the Hashemite monarchy and established Iraq as a republic.

Iraq War (2003–11): a war fought by a United States-led coalition against Iraq, which led to the deposing of the Iraqi dictator Saddam Hussein (1937–2006). After the war, coalition forces occupied Iraq until 2011, during which time they had to fight a sporadic insurgency.

Islamic State (of Syria and Iraq): a radical Islamist militant group that operates in Libya, Egypt, and other parts of the Middle East and Northern Africa and that, in 2014, took control of significant areas of Iraq and Syria.

Lebanese Civil War (1975–90): a sectarian civil war that took place in Lebanon between 1975 and 1990, pitting Christian, Sunni, and Shi'a militias against each other. The conflict also involved a number of foreign interventions by Syria, Israel, and the United States.

Levant: the eastern part of the Mediterranean, consisting of Cyprus, Lebanon, Palestine, and Syria.

Longue durée: a term meaning literally "long term," used first by the Annales School of history in France and subsequently by historians generally to outline a framework of analysis prioritizing very long-standing historical structures—particularly related to geographical and environmental factors—over short-term events.

Ma'rib: the capital city of the ancient Sabaean kingdom, often identified with the Biblical kingdom of Sheba, which flourished in northern Yemen between 500 B.C.E. and 575 C.E.

Maghrib: a North African region between the Atlantic Ocean and Egypt that includes Algeria, Tunisia, Libya, and parts of Morocco.

New social history: see Social History.

Oriental studies: an academic field concerned primarily with the study of the Middle and Far East with its roots in early European studies of these regions produced during the eighteenth and nineteenth centuries.

Ottoman Empire (1299–1923): a dynasty established by Osman I (Othman I) in northern Anatolia at the end of the thirteenth century and expanded by his successors to include all of Asia Minor, the Balkans, the Crimea, Iraq, Palestine, west and south Arabia, Egypt, Libya, and Tunisia until its collapse after World War I (1914–1918).

Palestinian Intifada (1987–93): an uprising by the Palestinians against Israeli occupation of the West Bank and Gaza Strip that resulted in the signing of the Oslo Accords six years later.

Palmyra: an ancient city in the desert of central Syria situated at an oasis on an important trade route between Mesopotamia and the Mediterranean.

Persian Gulf War: see Gulf War.

Philology: the study of the historical development, structure, and relationships of a language or languages.

Postmodernism: a late-twentieth-century concept used to describe arts, architecture, and criticism in ways that represent a departure from modernism.

Revisionism: the theory or practice of changing one's viewpoint to a previously accepted situation or stance.

Shi'ism: one of the two main branches of Islam and the leading religion in Iran. It separated from the Sunni sect after the prophet Muhammad died in 632 and believes that his true successor was the fourth caliph.

Six-Day War (1967): also known as the June War, the 1967 Arab-

Israeli War, and the Third Arab-Israeli War. It was fought between Egypt, Jordan, and Syria on one side and Israel on the other and resulted in a decisive victory for Israel and its capture of the Sinai Peninsula, the Gaza Strip, the West Bank, and the Golan Heights.

Social history: a broad branch of history focusing primarily on the experiences of ordinary people. Its influence increased rapidly from the 1960s onwards to become one of the most important trends in the study of history by the end of the twentieth century.

Soviet Union: a kind of "super state" that existed from 1922 to 1991, centered primarily on Russia and its neighbors. It was the communist pole of the Cold War.

Suez Crisis (1956): a short military conflict that began in 1956 following the nationalization of the Suez Canal by President Gamal Abdel Nasser of Egypt. Israel invaded Egypt, prompting British and French forces to intervene. The United States condemned this action and forced Britain and France to withdraw.

Sunni: one of the two main branches of Islam. Unlike the Shi'a sect, it honors the first three caliphs.

Syrian Islamist Uprising (1979–82): a series of revolts during the early 1980s by Sunni Islamists—who were mainly members of the Muslim Brotherhood—that the Syrian government put down violently. The uprising culminated in a massacre in Hama in 1982.

Third world: refers to the former colonial or semicolonial countries of Africa, Asia, and Latin America that were subject to European (or rather pan-European, including American and Russian) economic or political domination.

Transnational history: see World History.

World history: a field of history that examines the subject from a global perspective, looking for common patterns across cultures and structures linking them.

World War I (1914–18): an international conflict centered in Europe and involving the major economic world powers of the day.

World War II (1939–45): a global conflict fought between the Axis Powers (Germany, Italy, and Japan) and the victorious Allied Powers (the United Kingdom and its colonies, the Soviet Union, and the United States).

Yemen Civil War (1962–70): a civil war fought in North Yemen between royalist partisans backed by Saudi Arabia and Jordan and the supporters of the Yemen Arab Republic, which was backed by Egypt. The conflict came to an end following the Arab defeat during the June 1967 Six-Day War★ and the death of Gamal Abdel Nasser. It was a key conflict in the Arab Cold War.★

PEOPLE MENTIONED IN THE TEXT

George Antonius (1891–1942) was a leading Arab nationalist intellectual and author of the seminal The Arab Awakening: the Story of the Arab National Movement.

Aziz al-Azmeh (b. 1947) is a professor of Middle Eastern Studies at Central European University.

Jacques Berque (1910–95) was a French Arabist and historian of Islam who specialized in North Africa. Born in Algeria to French parents, he developed a profound knowledge of and respect for the societies he studied.

L. Carl Brown (b. 1928) is a professor of history at Princeton University focusing on the Middle East.

Richard Bulliet (b. 1940) is a professor of history at Columbia University. His research focuses on the history of Islamic society and institutions.

George W. Bush (b. 1947) was the 43rd President of the United States, serving two terms, from 2001 to 2009.

C. Ernest Dawn (b. 1918) was a professor of history at the University of Illinois. His research focuses on the Middle East.

Leila Fawaz is a professor of Lebanese and Eastern Mediterranean Studies at Tufts University.

Suraiya Faroqhi (b. 1941) is a German-born professor of the history

of the Ottoman Empire.

H. A. R. Gibb (1895–1971) was a Scottish-born professor of history at the University of Oxford. His research focused on Orientalism.

Michael Gilsenan is a professor of Middle Eastern and Islamic Studies and Anthropology at New York University.

Marshall Hodgson (1922–68) was an American historian of Islam most noted for his posthumously published masterpiece The Venture of Islam: Conscience and History in a World Civilization.

Samuel Huntingdon (1927–2008) was an influential American political scientist particularly noted for his analysis of international relations after the Cold War, which was based on the competition of various civilizational blocs. His most famous work is The Clash of Civilizations and the Remaking of the World Order.

Halil Inalcik (b. 1916) is a Turkish-born historian of the Ottoman Empire at Bilkent University, Turkey.

Malcolm Kerr (1931–86) was an American professor of the Middle East at American University of Beirut. Radical Islamists assassinated him in his office in 1986.

Ibn Khaldun (1332–1406) was an Arab historian born in Tunis who is regarded as one of the most significant historians of the Muslim world. His most famous work is Kitab al-'Ibar (*The Book of Learning by Example*).

Rashid Khalidi (b. 1948) is a Lebanese-born, Palestinian professor of history of the Middle East at Columbia University and director of the

Middle East Institute at Columbia's School of International and Public Affairs.

Ira Lapidus (b. 1936) is an American historian of Islam and the Middle East. He was a key figure in the development of Middle Eastern studies in the United States due to his emphasis in the field on methods drawn from across the social sciences.

Bernard Lewis (b. 1916) is a British historian of Islam most noted in academic circles for his work on the Ottoman Empire. He is also one of the most influential public intellectuals and commentators on the Middle East, particularly in the United States.

Charles Malik (1906–87) was a leading Lebanese philosopher, theologian, and diplomat, particularly noted for his interfaith activity.

Muhammad, the Prophet (570–632) was the prophet of the Muslim religion who founded Islam and unified Arabia into a single religion under Islam. His visions were transcribed into the Quran.

André Raymond (1925–2011) was an influential French historian of Islam who adopted the methods of the Annales School of history in his work.

Donald Malcolm Reid is a professor of history at Georgia State University and the author of Cairo University and the Making of Modern Egypt.

Edward Said (1935–2003) was a Palestinian literary theorist, critic, journalist and pro-Palestinian activist. He was a crucial figure in the development of post-colonial critical theory. His most famous work, Orientalism, is a foundational text.

Saladin (1137–93) was the sultan of Egypt and Syria from 1174 to 1193. He reconquered Jerusalem from the Christians in 1187, but was defeated by Richard the Lionheart in 1191.

Peter Sluglett is a professor of history at the University of Utah. His research focuses on the Middle East, particularly Iraq.

Arnold Joseph Toynbee (1889–1975) was an English historian and philosopher. He is best known for his 12-volume Study of History, which traced the rise and fall of different civilizations.

Constantine Zurayk (1909–2000) was a prominent Syrian Arab intellectual who was among the first to pioneer and express the importance of Arab nationalism.

WORKS CITED

WORKS CITED

Akyol, Mustafa. "Islam's Problem with Blasphemy." New York Times, January 13, 2015.

Al-Azmeh, Aziz. "Review: *A History of the Arab Peoples* by Albert Hourani." History Workshop Journal 40/1 (1995): 249–50.

Alkhateeb, Firas. Lost Islamic History: Reclaiming Muslim Civilization from the Past. New York: Hurst Publishers, 2014.

Antonius, George. The Arab Awakening: the Story of the Arab National Movement. London: Hamish Hamilton, 1938.

Berque, Jacques. Cultural Expression in Arab Society Today. Austen, TX: University of Texas Press, 1978.

Berque, Jacques. Egypt: Imperialism and Revolution. Translated by Jean Stewart. London: Faber, 1972.

Brown, L. Carl. "Empires in the Sand: Review: A History Of The Arab Peoples by Albert Hourani." New York Times, March 31, 1991.

Bulliet, Richard W. The Case for Islamo-Christian Civilization. New York: Columbia University Press, 2004.

Faroqhi, Suraiya. Subjects of the Sultan: Culture and Daily Life in the Ottoman Empire. London: I. B. Tauris, 2005.

Fawaz, Leila. A Land of Aching Hearts: The Middle East in the Great War. Cambridge: Harvard University Press, 2014.

Gilsenan, Michael. Saint and Sufi in Modern Egypt: An Essay in the Sociology of Religion. Oxford: Clarendon Press, 1973.

Goodman, L.E. "Arabic Thought in the Liberal Age, 1798-1939." The International History Review 8/1 (1986): 107-111.

Hitti, Philip K. History of the Arabs. London: Macmillan, 1937.

Hodgson, Marshall. The Venture of Islam: Conscience and History in a World Civilization. 3 vols. Chicago: University of Chicago, 1974.

Hourani, Albert, and S. M. Stern, eds. The Islamic City. Oxford: Oxford University Press, 1980.

Hourani, Albert, Philip S. Khoury, and Mary C. Wilson, eds. The Modern Middle East: a Reader. London: I. B. Tauris. 1993.

Hourani, Albert. Arabic Thought in the Liberal Age, 1789–1939. London: Oxford University Press, 1962.

_____. The Emergence of the Modern Middle East. London: Macmillan, 1981.

_____. A History of the Arab Peoples. 3rd ed. London: Faber and Faber, 2013.

_____. "How Should We Write the History of the Middle East?" International Journal of Middle East Studies 23 (1991): 125–36.

_____. Islam in European Thought. Cambridge: Cambridge University Press. 1991.

_____. "Patterns of the Past." Paths to the Middle East: Ten Scholars Look Back, edited by Thomas Naff. Albany: SUNY Press, 1993, 27–56.

Huntington, Samuel. The Clash of Civilizations and the Remaking of the World Order. New York: Simon & Schuster, 1996.

Inalcik, Halil. The Ottoman Empire: The Classical Age 1300-1600. New Haven, CT: Phoenix Press, 2001.

Inglehart, Ronald and Norris, Pippa. "The True Clash of Civilizations." Foreign Policy, November 4, 2009. http://foreignpolicy.com/2009/11/04/the-true-clash-of-civilizations/

Khalidi, Rashid. "Arab Nationalism: Historical Problems in the Literature." American Historical Review 95/1 (1991): 1365.

_____. British Policy towards Syria and Palestine, 1906–1914. Ithaca, NY: Ithaca University Press, 1980.

_____. Palestinian Identity: The Construction of Modern National Consciousness. New York: Columbia University Press, 1997.

Lapidus, Ira M. Muslim Cities in the Later Middle Ages. Cambridge: Harvard University Press, 1967.

Lewis, Bernard. The Arabs in History. London and New York: Hutchinson's University Library, 1950.

_____. What Went Wrong?: Western Impact and Middle Eastern Response. London: Weidenfield & Nicholson, 2002.

M.S.C, "Syria and Lebanon: A Political Essay by A. H. Hourani," World Affairs 109/4 (1946): 302.

Morgan, D. O. "Review: Islam in European Thought by Albert Hourani." Journal of Royal Asiatic Society 2/2 (1992): 261.

Nasr, Seyyed Hossein. Islam: Religion, History, and Civilization. London: HarperOne, 2002.

Quilliam, C. D. "Review: *Minorities in the Arab World* by A. H. Hourani." International Affairs 24/1 (1948): 138.

Raymond, André. Artisans et commerçants au Caire au XVIIIe siècle. Damascus: Institut Français de Damas, 1973.

Reid, Donald Malcolm. "Review: A History of the Arab Peoples by Albert Hourani." The International History Review 14/2 (1992): 347.

Said, Edward. Orientalism. New York: Vintage Books, 1979.

Saxon, Wolfgang. "Albert Hourani, 77, Acclaimed Mideast Scholar." New York Times, January 21, 1993.

Sluglett, Peter and Farouk-Sluglett, Marion. Iraq Since 1958: From Revolution to Dictatorship. London: I. B. Tauris, 2001.

Sluglett, Peter. Britain in Iraq: Contriving King and Country. New York: Columbia University Press, 2007.

Spagnolo, John, ed. Problems of the Modern Middle East in Historical Perspective: Essays in Honour of Albert Hourani. Reading: Ithaca Press, 1996.

Sudairi, Abdulaziz A. Al-. A Vision of the Middle East: An Intellectual Biography of Albert Hourani. London: I. B. Tauris, 2000.

Toynbee, Arnold. The Study of History. 12 vols. Oxford: Oxford University Press, 1934–1961.

Vatikiotis, P. J. "Albert Hourani: In Memoriam." Middle Eastern Studies 29/2 (1993): 370–71.

Yuan, Xingpei and Yan, Wenming. The History of Chinese Civilization Cambridge: Cambridge University Press, 2012.

THE MACAT LIBRARY
BY DISCIPLINE

AFRICANA STUDIES

Chinua Achebe's *An Image of Africa: Racism in Conrad's Heart of Darkness*
W. E. B. Du Bois's *The Souls of Black Folk*
Zora Neale Huston's *Characteristics of Negro Expression*
Martin Luther King Jr's *Why We Can't Wait*
Toni Morrison's *Playing in the Dark: Whiteness in the American Literary Imagination*

ANTHROPOLOGY

Arjun Appadurai's *Modernity at Large: Cultural Dimensions of Globalisation*
Philippe Ariès's *Centuries of Childhood*
Franz Boas's *Race, Language and Culture*
Kim Chan & Renée Mauborgne's *Blue Ocean Strategy*
Jared Diamond's *Guns, Germs & Steel: the Fate of Human Societies*
Jared Diamond's *Collapse: How Societies Choose to Fail or Survive*
E. E. Evans-Pritchard's *Witchcraft, Oracles and Magic Among the Azande*
James Ferguson's *The Anti-Politics Machine*
Clifford Geertz's *The Interpretation of Cultures*
David Graeber's *Debt: the First 5000 Years*
Karen Ho's *Liquidated: An Ethnography of Wall Street*
Geert Hofstede's *Culture's Consequences: Comparing Values, Behaviors, Institutes and Organizations across Nations*
Claude Lévi-Strauss's *Structural Anthropology*
Jay Macleod's *Ain't No Makin' It: Aspirations and Attainment in a Low-Income Neighborhood*
Saba Mahmood's *The Politics of Piety: The Islamic Revival and the Feminist Subjec*t
Marcel Mauss's *The Gift*

BUSINESS

Jean Lave & Etienne Wenger's *Situated Learning*
Theodore Levitt's *Marketing Myopia*
Burton G. Malkiel's *A Random Walk Down Wall Street*
Douglas McGregor's *The Human Side of Enterprise*
Michael Porter's *Competitive Strategy: Creating and Sustaining Superior Performance*
John Kotter's *Leading Change*
C. K. Prahalad & Gary Hamel's *The Core Competence of the Corporation*

CRIMINOLOGY

Michelle Alexander's *The New Jim Crow: Mass Incarceration in the Age of Colorblindness*
Michael R. Gottfredson & Travis Hirschi's *A General Theory of Crime*
Richard Herrnstein & Charles A. Murray's *The Bell Curve: Intelligence and Class Structure in American Life*
Elizabeth Loftus's *Eyewitness Testimony*
Jay Macleod's *Ain't No Makin' It: Aspirations and Attainment in a Low-Income Neighborhood*
Philip Zimbardo's *The Lucifer Effect*

ECONOMICS

Janet Abu-Lughod's *Before European Hegemony*
Ha-Joon Chang's *Kicking Away the Ladder*
David Brion Davis's *The Problem of Slavery in the Age of Revolution*
Milton Friedman's *The Role of Monetary Policy*
Milton Friedman's *Capitalism and Freedom*
David Graeber's *Debt: the First 5000 Years*
Friedrich Hayek's *The Road to Serfdom*
Karen Ho's *Liquidated: An Ethnography of Wall Street*

John Maynard Keynes's *The General Theory of Employment, Interest and Money*
Charles P. Kindleberger's *Manias, Panics and Crashes*
Robert Lucas's *Why Doesn't Capital Flow from Rich to Poor Countries?*
Burton G. Malkiel's *A Random Walk Down Wall Street*
Thomas Robert Malthus's *An Essay on the Principle of Population*
Karl Marx's *Capital*
Thomas Piketty's *Capital in the Twenty-First Century*
Amartya Sen's *Development as Freedom*
Adam Smith's *The Wealth of Nations*
Nassim Nicholas Taleb's *The Black Swan: The Impact of the Highly Improbable*
Amos Tversky's & Daniel Kahneman's *Judgment under Uncertainty: Heuristics and Biases*
Mahbub Ul Haq's *Reflections on Human Development*
Max Weber's *The Protestant Ethic and the Spirit of Capitalism*

FEMINISM AND GENDER STUDIES

Judith Butler's *Gender Trouble*
Simone De Beauvoir's *The Second Sex*
Michel Foucault's *History of Sexuality*
Betty Friedan's *The Feminine Mystique*
Saba Mahmood's *The Politics of Piety: The Islamic Revival and the Feminist Subject*
Joan Wallach Scott's *Gender and the Politics of History*
Mary Wollstonecraft's *A Vindication of the Rights of Woman*
Virginia Woolf's *A Room of One's Own*

GEOGRAPHY

The Brundtland Report's *Our Common Future*
Rachel Carson's *Silent Spring*
Charles Darwin's *On the Origin of Species*
James Ferguson's *The Anti-Politics Machine*
Jane Jacobs's *The Death and Life of Great American Cities*
James Lovelock's *Gaia: A New Look at Life on Earth*
Amartya Sen's *Development as Freedom*
Mathis Wackernagel & William Rees's *Our Ecological Footprint*

HISTORY

Janet Abu-Lughod's *Before European Hegemony*
Benedict Anderson's *Imagined Communities*
Bernard Bailyn's *The Ideological Origins of the American Revolution*
Hanna Batatu's *The Old Social Classes And The Revolutionary Movements Of Iraq*
Christopher Browning's *Ordinary Men: Reserve Police Batallion 101 and the Final Solution in Poland*
Edmund Burke's *Reflections on the Revolution in France*
William Cronon's *Nature's Metropolis: Chicago And The Great West*
Alfred W. Crosby's *The Columbian Exchange*
Hamid Dabashi's *Iran: A People Interrupted*
David Brion Davis's *The Problem of Slavery in the Age of Revolution*
Nathalie Zemon Davis's *The Return of Martin Guerre*
Jared Diamond's *Guns, Germs & Steel: the Fate of Human Societies*
Frank Dikotter's *Mao's Great Famine*
John W Dower's *War Without Mercy: Race And Power In The Pacific War*
W. E. B. Du Bois's *The Souls of Black Folk*
Richard J. Evans's *In Defence of History*
Lucien Febvre's *The Problem of Unbelief in the 16th Century*
Sheila Fitzpatrick's *Everyday Stalinism*

Eric Foner's *Reconstruction: America's Unfinished Revolution, 1863-1877*
Michel Foucault's *Discipline and Punish*
Michel Foucault's *History of Sexuality*
Francis Fukuyama's *The End of History and the Last Man*
John Lewis Gaddis's *We Now Know: Rethinking Cold War History*
Ernest Gellner's *Nations and Nationalism*
Eugene Genovese's *Roll, Jordan, Roll: The World the Slaves Made*
Carlo Ginzburg's *The Night Battles*
Daniel Goldhagen's *Hitler's Willing Executioners*
Jack Goldstone's *Revolution and Rebellion in the Early Modern World*
Antonio Gramsci's *The Prison Notebooks*
Alexander Hamilton, John Jay & James Madison's *The Federalist Papers*
Christopher Hill's *The World Turned Upside Down*
Carole Hillenbrand's *The Crusades: Islamic Perspectives*
Thomas Hobbes's *Leviathan*
Eric Hobsbawm's *The Age Of Revolution*
John A. Hobson's *Imperialism: A Study*
Albert Hourani's *History of the Arab Peoples*
Samuel P. Huntington's *The Clash of Civilizations and the Remaking of World Order*
C. L. R. James's *The Black Jacobins*
Tony Judt's *Postwar: A History of Europe Since 1945*
Ernst Kantorowicz's *The King's Two Bodies: A Study in Medieval Political Theology*
Paul Kennedy's *The Rise and Fall of the Great Powers*
Ian Kershaw's *The "Hitler Myth": Image and Reality in the Third Reich*
John Maynard Keynes's *The General Theory of Employment, Interest and Money*
Charles P. Kindleberger's *Manias, Panics and Crashes*
Martin Luther King Jr's *Why We Can't Wait*
Henry Kissinger's *World Order: Reflections on the Character of Nations and the Course of History*
Thomas Kuhn's *The Structure of Scientific Revolutions*
Georges Lefebvre's *The Coming of the French Revolution*
John Locke's *Two Treatises of Government*
Niccolò Machiavelli's *The Prince*
Thomas Robert Malthus's *An Essay on the Principle of Population*
Mahmood Mamdani's *Citizen and Subject: Contemporary Africa And The Legacy Of Late Colonialism*
Karl Marx's *Capital*
Stanley Milgram's *Obedience to Authority*
John Stuart Mill's *On Liberty*
Thomas Paine's *Common Sense*
Thomas Paine's *Rights of Man*
Geoffrey Parker's *Global Crisis: War, Climate Change and Catastrophe in the Seventeenth Century*
Jonathan Riley-Smith's *The First Crusade and the Idea of Crusading*
Jean-Jacques Rousseau's *The Social Contract*
Joan Wallach Scott's *Gender and the Politics of History*
Theda Skocpol's *States and Social Revolutions*
Adam Smith's *The Wealth of Nations*
Timothy Snyder's *Bloodlands: Europe Between Hitler and Stalin*
Sun Tzu's *The Art of War*
Keith Thomas's *Religion and the Decline of Magic*
Thucydides's *The History of the Peloponnesian War*
Frederick Jackson Turner's *The Significance of the Frontier in American History*
Odd Arne Westad's *The Global Cold War: Third World Interventions And The Making Of Our Times*

LITERATURE

Chinua Achebe's *An Image of Africa: Racism in Conrad's Heart of Darkness*
Roland Barthes's *Mythologies*
Homi K. Bhabha's *The Location of Culture*
Judith Butler's *Gender Trouble*
Simone De Beauvoir's *The Second Sex*
Ferdinand De Saussure's *Course in General Linguistics*
T. S. Eliot's *The Sacred Wood: Essays on Poetry and Criticism*
Zora Neale Huston's *Characteristics of Negro Expression*
Toni Morrison's *Playing in the Dark: Whiteness in the American Literary Imagination*
Edward Said's *Orientalism*
Gayatri Chakravorty Spivak's *Can the Subaltern Speak?*
Mary Wollstonecraft's *A Vindication of the Rights of Women*
Virginia Woolf's *A Room of One's Own*

PHILOSOPHY

Elizabeth Anscombe's *Modern Moral Philosophy*
Hannah Arendt's *The Human Condition*
Aristotle's *Metaphysics*
Aristotle's *Nicomachean Ethics*
Edmund Gettier's *Is Justified True Belief Knowledge?*
Georg Wilhelm Friedrich Hegel's *Phenomenology of Spirit*
David Hume's *Dialogues Concerning Natural Religion*
David Hume's *The Enquiry for Human Understanding*
Immanuel Kant's *Religion within the Boundaries of Mere Reason*
Immanuel Kant's *Critique of Pure Reason*
Søren Kierkegaard's *The Sickness Unto Death*
Søren Kierkegaard's *Fear and Trembling*
C. S. Lewis's *The Abolition of Man*
Alasdair MacIntyre's *After Virtue*
Marcus Aurelius's *Meditations*
Friedrich Nietzsche's *On the Genealogy of Morality*
Friedrich Nietzsche's *Beyond Good and Evil*
Plato's *Republic*
Plato's *Symposium*
Jean-Jacques Rousseau's *The Social Contract*
Gilbert Ryle's *The Concept of Mind*
Baruch Spinoza's *Ethics*
Sun Tzu's *The Art of War*
Ludwig Wittgenstein's *Philosophical Investigations*

POLITICS

Benedict Anderson's *Imagined Communities*
Aristotle's *Politics*
Bernard Bailyn's *The Ideological Origins of the American Revolution*
Edmund Burke's *Reflections on the Revolution in France*
John C. Calhoun's *A Disquisition on Government*
Ha-Joon Chang's *Kicking Away the Ladder*
Hamid Dabashi's *Iran: A People Interrupted*
Hamid Dabashi's *Theology of Discontent: The Ideological Foundation of the Islamic Revolution in Iran*
Robert Dahl's *Democracy and its Critics*
Robert Dahl's *Who Governs?*
David Brion Davis's *The Problem of Slavery in the Age of Revolution*

The Macat Library By Discipline

Alexis De Tocqueville's *Democracy in America*
James Ferguson's *The Anti-Politics Machine*
Frank Dikotter's *Mao's Great Famine*
Sheila Fitzpatrick's *Everyday Stalinism*
Eric Foner's *Reconstruction: America's Unfinished Revolution, 1863-1877*
Milton Friedman's *Capitalism and Freedom*
Francis Fukuyama's *The End of History and the Last Man*
John Lewis Gaddis's *We Now Know: Rethinking Cold War History*
Ernest Gellner's *Nations and Nationalism*
David Graeber's *Debt: the First 5000 Years*
Antonio Gramsci's *The Prison Notebooks*
Alexander Hamilton, John Jay & James Madison's *The Federalist Papers*
Friedrich Hayek's *The Road to Serfdom*
Christopher Hill's *The World Turned Upside Down*
Thomas Hobbes's *Leviathan*
John A. Hobson's *Imperialism: A Study*
Samuel P. Huntington's *The Clash of Civilizations and the Remaking of World Order*
Tony Judt's *Postwar: A History of Europe Since 1945*
David C. Kang's *China Rising: Peace, Power and Order in East Asia*
Paul Kennedy's *The Rise and Fall of Great Powers*
Robert Keohane's *After Hegemony*
Martin Luther King Jr.'s *Why We Can't Wait*
Henry Kissinger's *World Order: Reflections on the Character of Nations and the Course of History*
John Locke's *Two Treatises of Government*
Niccolò Machiavelli's *The Prince*
Thomas Robert Malthus's *An Essay on the Principle of Population*
Mahmood Mamdani's *Citizen and Subject: Contemporary Africa And The Legacy Of Late Colonialism*
Karl Marx's *Capital*
John Stuart Mill's *On Liberty*
John Stuart Mill's *Utilitarianism*
Hans Morgenthau's *Politics Among Nations*
Thomas Paine's *Common Sense*
Thomas Paine's *Rights of Man*
Thomas Piketty's *Capital in the Twenty-First Century*
Robert D. Putman's *Bowling Alone*
John Rawls's *Theory of Justice*
Jean-Jacques Rousseau's *The Social Contract*
Theda Skocpol's *States and Social Revolutions*
Adam Smith's *The Wealth of Nations*
Sun Tzu's *The Art of War*
Henry David Thoreau's *Civil Disobedience*
Thucydides's *The History of the Peloponnesian War*
Kenneth Waltz's *Theory of International Politics*
Max Weber's *Politics as a Vocation*
Odd Arne Westad's *The Global Cold War: Third World Interventions And The Making Of Our Times*

POSTCOLONIAL STUDIES

Roland Barthes's *Mythologies*
Frantz Fanon's *Black Skin, White Masks*
Homi K. Bhabha's *The Location of Culture*
Gustavo Gutiérrez's *A Theology of Liberation*
Edward Said's *Orientalism*
Gayatri Chakravorty Spivak's *Can the Subaltern Speak?*

PSYCHOLOGY

Gordon Allport's *The Nature of Prejudice*
Alan Baddeley & Graham Hitch's *Aggression: A Social Learning Analysis*
Albert Bandura's *Aggression: A Social Learning Analysis*
Leon Festinger's *A Theory of Cognitive Dissonance*
Sigmund Freud's *The Interpretation of Dreams*
Betty Friedan's *The Feminine Mystique*
Michael R. Gottfredson & Travis Hirschi's *A General Theory of Crime*
Eric Hoffer's *The True Believer: Thoughts on the Nature of Mass Movements*
William James's *Principles of Psychology*
Elizabeth Loftus's *Eyewitness Testimony*
A. H. Maslow's *A Theory of Human Motivation*
Stanley Milgram's *Obedience to Authority*
Steven Pinker's *The Better Angels of Our Nature*
Oliver Sacks's *The Man Who Mistook His Wife For a Hat*
Richard Thaler & Cass Sunstein's *Nudge: Improving Decisions About Health, Wealth and Happiness*
Amos Tversky's *Judgment under Uncertainty: Heuristics and Biases*
Philip Zimbardo's *The Lucifer Effect*

SCIENCE

Rachel Carson's *Silent Spring*
William Cronon's *Nature's Metropolis: Chicago And The Great West*
Alfred W. Crosby's *The Columbian Exchange*
Charles Darwin's *On the Origin of Species*
Richard Dawkin's *The Selfish Gene*
Thomas Kuhn's *The Structure of Scientific Revolutions*
Geoffrey Parker's *Global Crisis: War, Climate Change and Catastrophe in the Seventeenth Century*
Mathis Wackernagel & William Rees's *Our Ecological Footprint*

SOCIOLOGY

Michelle Alexander's *The New Jim Crow: Mass Incarceration in the Age of Colorblindness*
Gordon Allport's *The Nature of Prejudice*
Albert Bandura's *Aggression: A Social Learning Analysis*
Hanna Batatu's *The Old Social Classes And The Revolutionary Movements Of Iraq*
Ha-Joon Chang's *Kicking Away the Ladder*
W. E. B. Du Bois's *The Souls of Black Folk*
Émile Durkheim's *On Suicide*
Frantz Fanon's *Black Skin, White Masks*
Frantz Fanon's *The Wretched of the Earth*
Eric Foner's *Reconstruction: America's Unfinished Revolution, 1863-1877*
Eugene Genovese's *Roll, Jordan, Roll: The World the Slaves Made*
Jack Goldstone's *Revolution and Rebellion in the Early Modern World*
Antonio Gramsci's *The Prison Notebooks*
Richard Herrnstein & Charles A Murray's *The Bell Curve: Intelligence and Class Structure in American Life*
Eric Hoffer's *The True Believer: Thoughts on the Nature of Mass Movements*
Jane Jacobs's *The Death and Life of Great American Cities*
Robert Lucas's *Why Doesn't Capital Flow from Rich to Poor Countries?*
Jay Macleod's *Ain't No Makin' It: Aspirations and Attainment in a Low Income Neighborhood*
Elaine May's *Homeward Bound: American Families in the Cold War Era*
Douglas McGregor's *The Human Side of Enterprise*
C. Wright Mills's *The Sociological Imagination*

The Macat Library By Discipline

Thomas Piketty's *Capital in the Twenty-First Century*
Robert D. Putman's *Bowling Alone*
David Riesman's *The Lonely Crowd: A Study of the Changing American Character*
Edward Said's *Orientalism*
Joan Wallach Scott's *Gender and the Politics of History*
Theda Skocpol's *States and Social Revolutions*
Max Weber's *The Protestant Ethic and the Spirit of Capitalism*

THEOLOGY

Augustine's *Confessions*
Benedict's *Rule of St Benedict*
Gustavo Gutiérrez's *A Theology of Liberation*
Carole Hillenbrand's *The Crusades: Islamic Perspectives*
David Hume's *Dialogues Concerning Natural Religion*
Immanuel Kant's *Religion within the Boundaries of Mere Reason*
Ernst Kantorowicz's *The King's Two Bodies: A Study in Medieval Political Theology*
Søren Kierkegaard's *The Sickness Unto Death*
C. S. Lewis's *The Abolition of Man*
Saba Mahmood's *The Politics of Piety: The Islamic Revival and the Feminist Subject*
Baruch Spinoza's *Ethics*
Keith Thomas's *Religion and the Decline of Magic*

COMING SOON

Chris Argyris's *The Individual and the Organisation*
Seyla Benhabib's *The Rights of Others*
Walter Benjamin's *The Work Of Art in the Age of Mechanical Reproduction*
John Berger's *Ways of Seeing*
Pierre Bourdieu's *Outline of a Theory of Practice*
Mary Douglas's *Purity and Danger*
Roland Dworkin's *Taking Rights Seriously*
James G. March's *Exploration and Exploitation in Organisational Learning*
Ikujiro Nonaka's *A Dynamic Theory of Organizational Knowledge Creation*
Griselda Pollock's *Vision and Difference*
Amartya Sen's *Inequality Re-Examined*
Susan Sontag's *On Photography*
Yasser Tabbaa's *The Transformation of Islamic Art*
Ludwig von Mises's *Theory of Money and Credit*

MACAT

The World's Greatest Books, Analysed Within One Multimedia Library

Sign Up To The Macat iLibrary Today

**Get hundreds of Macat analyses on
your phone, tablet and desktop**
•
**Study within a time that suits you, using our
3-minute, 10-minute or 3-hour modules**
•
**Access a complete set of multimedia tools, including
video, flash cards, mind maps and audiobooks**
•
New titles added every year

Join free for one month
library.macat.com

Macat Disciplines

Access the greatest ideas and thinkers across entire disciplines, including

Postcolonial Studies

Roland Barthes's *Mythologies*
Frantz Fanon's *Black Skin, White Masks*
Homi K. Bhabha's *The Location of Culture*
Gustavo Gutiérrez's *A Theology of Liberation*
Edward Said's *Orientalism*
Gayatri Chakravorty Spivak's *Can the Subaltern Speak?*

Macat Disciplines

Access the greatest ideas and thinkers across entire disciplines, including

AFRICANA STUDIES

Chinua Achebe's *An Image of Africa: Racism in Conrad's Heart of Darkness*

W. E. B. Du Bois's *The Souls of Black Folk*

Zora Neale Hurston's *Characteristics of Negro Expression*

Martin Luther King Jr.'s *Why We Can't Wait*

Toni Morrison's *Playing in the Dark: Whiteness in the American Literary Imagination*

Macat analyses are available from all good bookshops and libraries.

Access hundreds of analyses through one, multimedia tool.
Join free for one month **library.macat.com**

Macat Disciplines

Access the greatest ideas and thinkers across entire disciplines, including

FEMINISM, GENDER AND QUEER STUDIES

Simone De Beauvoir's
The Second Sex

Michel Foucault's
History of Sexuality

Betty Friedan's
The Feminine Mystique

Saba Mahmood's
The Politics of Piety: The Islamic Revival and the Feminist Subject

Joan Wallach Scott's
Gender and the Politics of History

Mary Wollstonecraft's
A Vindication of the Rights of Woman

Virginia Woolf's
A Room of One's Own

Judith Butler's
Gender Trouble

Macat analyses are available from all good bookshops and libraries.

Access hundreds of analyses through one, multimedia tool.
Join free for one month **library.macat.com**

Macat Disciplines

Access the greatest ideas and thinkers across entire disciplines, including

CRIMINOLOGY

Michelle Alexander's
*The New Jim Crow:
Mass Incarceration in the
Age of Colorblindness*

**Michael R. Gottfredson
& Travis Hirschi's**
A General Theory of Crime

Elizabeth Loftus's
Eyewitness Testimony

**Richard Herrnstein
& Charles A. Murray's**
*The Bell Curve: Intelligence and
Class Structure in American Life*

Jay Macleod's
*Ain't No Makin' It:
Aspirations and Attainment in a
Low-Income Neighborhood*

Philip Zimbardo's
The Lucifer Effect

Macat analyses are available from all good bookshops and libraries.

Access hundreds of analyses through one, multimedia tool.
Join free for one month **library.macat.com**

Macat Disciplines

Access the greatest ideas and thinkers across entire disciplines, including

INEQUALITY

Ha-Joon Chang's, *Kicking Away the Ladder*

David Graeber's, *Debt: The First 5000 Years*

Robert E. Lucas's, *Why Doesn't Capital Flow from Rich To Poor Countries?*

Thomas Piketty's, *Capital in the Twenty-First Century*

Amartya Sen's, *Inequality Re-Examined*

Mahbub Ul Haq's, *Reflections on Human Development*

Macat analyses are available from all good bookshops and libraries.

Access hundreds of analyses through one, multimedia tool.

Join free for one month **library.macat.com**

Macat Disciplines

*Access the greatest ideas and thinkers
across entire disciplines, including*

GLOBALIZATION

Arjun Appadurai's, *Modernity at Large:
Cultural Dimensions of Globalisation*

James Ferguson's, *The Anti-Politics Machine*

Geert Hofstede's, *Culture's Consequences*

Amartya Sen's, *Development as Freedom*

Macat Disciplines

Access the greatest ideas and thinkers across entire disciplines, including

MAN AND THE ENVIRONMENT

The Brundtland Report's, *Our Common Future*
Rachel Carson's, *Silent Spring*
James Lovelock's, *Gaia: A New Look at Life on Earth*
Mathis Wackernagel & William Rees's, *Our Ecological Footprint*

Macat analyses are available from all good bookshops and libraries.

Access hundreds of analyses through one, multimedia tool.
Join free for one month **library.macat.com**

Macat Disciplines

Access the greatest ideas and thinkers across entire disciplines, including

TOTALITARIANISM

Sheila Fitzpatrick's, *Everyday Stalinism*
Ian Kershaw's, *The "Hitler Myth"*
Timothy Snyder's, *Bloodlands*

Macat Pairs

Analyse historical and modern issues from opposite sides of an argument. Pairs include:

RACE AND IDENTITY

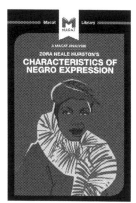

Zora Neale Hurston's
Characteristics of Negro Expression

Using material collected on anthropological expeditions to the South, Zora Neale Hurston explains how expression in African American culture in the early twentieth century departs from the art of white America. At the time, African American art was often criticized for copying white culture. For Hurston, this criticism misunderstood how art works. European tradition views art as something fixed. But Hurston describes a creative process that is alive, ever-changing, and largely improvisational. She maintains that African American art works through a process called 'mimicry'—where an imitated object or verbal pattern, for example, is reshaped and altered until it becomes something new, novel—and worthy of attention.

Frantz Fanon's
Black Skin, White Masks

Black Skin, White Masks offers a radical analysis of the psychological effects of colonization on the colonized.

Fanon witnessed the effects of colonization first hand both in his birthplace, Martinique, and again later in life when he worked as a psychiatrist in another French colony, Algeria. His text is uncompromising in form and argument. He dissects the dehumanizing effects of colonialism, arguing that it destroys the native sense of identity, forcing people to adapt to an alien set of values—including a core belief that they are inferior. This results in deep psychological trauma.

Fanon's work played a pivotal role in the civil rights movements of the 1960s.

Macat analyses are available from all good bookshops and libraries.

Access hundreds of analyses through one, multimedia tool.
Join free for one month **library.macat.com**

Macat Pairs

Analyse historical and modern issues from opposite sides of an argument. Pairs include:

INTERNATIONAL RELATIONS IN THE 21ST CENTURY

Samuel P. Huntington's
The Clash of Civilisations

In his highly influential 1996 book, Huntington offers a vision of a post-Cold War world in which conflict takes place not between competing ideologies but between cultures. The worst clash, he argues, will be between the Islamic world and the West: the West's arrogance and belief that its culture is a "gift" to the world will come into conflict with Islam's obstinacy and concern that its culture is under attack from a morally decadent "other."

Clash inspired much debate between different political schools of thought. But its greatest impact came in helping define American foreign policy in the wake of the 2001 terrorist attacks in New York and Washington.

Francis Fukuyama's
The End of History and the Last Man

Published in 1992, *The End of History and the Last Man* argues that capitalist democracy is the final destination for all societies. Fukuyama believed democracy triumphed during the Cold War because it lacks the "fundamental contradictions" inherent in communism and satisfies our yearning for freedom and equality. Democracy therefore marks the endpoint in the evolution of ideology, and so the "end of history." There will still be "events," but no fundamental change in ideology.

Macat Pairs

*Analyse historical and modern issues
from opposite sides of an argument.
Pairs include:*

HOW TO RUN AN ECONOMY

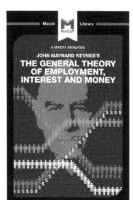

John Maynard Keynes's
*The General Theory OF Employment,
Interest and Money*

Classical economics suggests that market economies
are self-correcting in times of recession or depression,
and tend toward full employment and output. But
English economist John Maynard Keynes disagrees.

In his ground-breaking 1936 study *The General
Theory*, Keynes argues that traditional economics
has misunderstood the causes of unemployment.
Employment is not determined by the price of labor;
it is directly linked to demand. Keynes believes market
economies are by nature unstable, and so require
government intervention. Spurred on by the social
catastrophe of the Great Depression of the 1930s,
he sets out to revolutionize the way the world thinks

Milton Friedman's
The Role of Monetary Policy

Friedman's 1968 paper changed the course of
economic theory. In just 17 pages, he demolished
existing theory and outlined an effective alternate
monetary policy designed to secure 'high employment,
stable prices and rapid growth.'

Friedman demonstrated that monetary policy plays
a vital role in broader economic stability and argued
that economists got their monetary policy wrong
in the 1950s and 1960s by misunderstanding the
relationship between inflation and unemployment.
Previous generations of economists had believed
that governments could permanently decrease
unemployment by permitting inflation—and vice versa.
Friedman's most original contribution was to show that
this supposed trade-off is an illusion that only works in
the short term.

Macat analyses are available from all good bookshops and libraries.

Access hundreds of analyses through one, multimedia tool.
Join free for one month **library.macat.com**

Macat Pairs

Analyse historical and modern issues from opposite sides of an argument. Pairs include:

ARE WE FUNDAMENTALLY GOOD - OR BAD?

Steven Pinker's
The Better Angels of Our Nature

Stephen Pinker's gloriously optimistic 2011 book argues that, despite humanity's biological tendency toward violence, we are, in fact, less violent today than ever before. To prove his case, Pinker lays out pages of detailed statistical evidence. For him, much of the credit for the decline goes to the eighteenth-century Enlightenment movement, whose ideas of liberty, tolerance, and respect for the value of human life filtered down through society and affected how people thought. That psychological change led to behavioral change—and overall we became more peaceful. Critics countered that humanity could never overcome the biological urge toward violence; others argued that Pinker's statistics were flawed.

Philip Zimbardo's
The Lucifer Effect

Some psychologists believe those who commit cruelty are innately evil. Zimbardo disagrees. In *The Lucifer Effect*, he argues that sometimes good people do evil things simply because of the situations they find themselves in, citing many historical examples to illustrate his point. Zimbardo details his 1971 Stanford prison experiment, where ordinary volunteers playing guards in a mock prison rapidly became abusive. But he also describes the tortures committed by US army personnel in Iraq's Abu Ghraib prison in 2003—and how he himself testified in defence of one of those guards. committed by US army personnel in Iraq's Abu Ghraib prison in 2003—and how he himself testified in defence of one of those guards.

Macat analyses are available from all good bookshops and libraries.

Access hundreds of analyses through one, multimedia tool.
Join free for one month **library.macat.com**

Macat Pairs

Analyse historical and modern issues from opposite sides of an argument. Pairs include:

Jean-Jacques Rousseau's
The Social Contract

Rousseau's famous work sets out the radical concept of the 'social contract': a give-and-take relationship between individual freedom and social order.

If people are free to do as they like, governed only by their own sense of justice, they are also vulnerable to chaos and violence. To avoid this, Rousseau proposes, they should agree to give up some freedom to benefit from the protection of social and political organization. But this deal is only just if societies are led by the collective needs and desires of the people, and able to control the private interests of individuals. For Rousseau, the only legitimate form of government is rule by the people.

Robert D. Putnam's
Bowling Alone

In *Bowling Alone*, Robert Putnam argues that Americans have become disconnected from one another and from the institutions of their common life, and investigates the consequences of this change.

Looking at a range of indicators, from membership in formal organizations to the number of invitations being extended to informal dinner parties, Putnam demonstrates that Americans are interacting less and creating less "social capital" – with potentially disastrous implications for their society.

It would be difficult to overstate the impact of *Bowling Alone*, one of the most frequently cited social science publications of the last half-century.

Printed in the United States
by Baker & Taylor Publisher Services